DRAW

DRAW

A FAST, FUN & EFFECTIVE WAY TO LEARN

JAKE SPICER

ilex

DRAW

An Hachette UK Company
www.hachette.co.uk

First published in the United Kingdom in 2015 by
ILEX, a division of Octopus Publishing Group Ltd

Octopus Publishing Group
Carmelite House
50 Victoria Embankment
London, EC4Y 0DZ
www.octopusbooks.co.uk

Design, layout, and text copyright
© Octopus Publishing Group 2015

Jake Spicer asserts the moral right to be identified
as the author of this work.

Publisher: Roly Allen
Commissioning Editor: Zara Larcombe
Assistant Editor: Rachel Silverlight
Senior Project Editor: Natalia Price-Cabrera
Senior Specialist Editor: Frank Gallaugher
Art Director: Julie Weir
Designer: Made Noise
Senior Production Manager: Marina Maher

ISBN 978-1-78157-304-4

A CIP catalogue record for this book is available
from the British Library

Printed and bound in China

10 9 8 7 6 5 4 3 2 1

CONTENTS

WHY DRAW?

Everybody can learn to draw, and anyone who can draw can always improve. Many of us fall out of drawing at a young age, some of us keep drawing sporadically, and some of us make it part of our day-to-day routine. Whatever your level of experience, the only way to get better at drawing is to draw more. This book is intended to give you confidence in your own drawing and to make it easy to fit drawing into your life.

PICTURE MAKING

A drawing can be a picture; a representation of a thing we have seen or imagined. Drawing as a process is an immediate way of structuring an observation or bringing an idea into being. Painters, printmakers, and anybody making pictures and objects in any medium will benefit from developing fundamental drawing skills. Drawing as a sensibility can extend beyond the conventional mediums we associate with it; sketches can be made in paint, film, built in three-dimensions, and so on. For the purpose of this book I'll be writing about drawing in its most conventional form.

VISUAL COMMUNICATION

Modern image-making techniques tend to be largely mechanical or digital, and so drawing is now commonly seen as an artistic practice. Anything can be art, so drawing can be art for sure, but it needn't be restricted to artistic uses. Think of drawing as a language. Written language can be used in different ways to write poetry, academic papers, washing machine instructions, and road signs. Drawing is a similarly versatile visual language with its own vocabulary of marks that can be used for many applications. Whether you are drawing a map to give somebody directions, sketching a diagram to explain how to place furniture in a room, or storyboarding an animation in visual snapshots, some ideas are just more efficiently represented by drawing.

DRAWING AS A THINKING TOOL

Almost every man-made thing that we see around us started as a drawing: from buildings, to furniture, to posters, to stationary. As an aid to thinking, sketching something visual on paper allows us to explore ideas in a holistic way rather than pinning them down to fixed linguistic concepts, and drawings made in versatile mediums like pencil can easily be adapted as the idea evolves. Just like any language, drawing can be used playfully, providing an outlet for creative thought and emotional expression, channeled through the tactile process of mark-making.

LEARNING TO SEE

Observational drawing is a means of exercising our visual faculty, and it allows us to practice looking. It can also be a powerful tool for focusing our attention, in the way that it teaches us to select a subject's most important qualities and make visual discoveries, encouraging curiosity and improved understanding.

We are constantly bombarded with visual imagery; becoming more visually literate allows us to be discerning about how we look and how we are affected by the images we come into contact with. As we get older, we also look less closely at familiar things; drawing can open our eyes to a fresh and childlike wonder in the mundane.

HOW DO I DRAW MORE OFTEN?

To draw better, you'll need to find the time to draw more often. Drawing requires some attention and focus and this book is intended to help you. Treat it like a kind but firm friend, politely reminding you that to get better you'll need to put some work in, and this is how to do it. Firstly, you want to remove the barriers that stop you from drawing, making it easy to find time and motivation to draw.

TIME

Don't have time to draw? Make the time. Start with a few manageable goals and use the exercises in this book to structure them. Attempt 3–4 exercises in a week, or find a way to work drawing into another regular activity; sketch fellow passengers on the morning commute, for example, or draw in the kitchen while waiting for the kettle to boil. Use the time in between other activities to provide a foundation of regular practice, then put aside an hour or two on top of that to sit down and draw in earnest at home or at an art class.

SUBJECT

Nothing to draw? There are things to draw everywhere; the trick is finding subjects that you find interesting. Learn to see interest in the mundane and use the practical advice in Chapter 3 to help you. Work out where your interests lie; do you enjoy drawing natural forms? Figures? Buildings? Start looking for potential subjects everywhere you go, seek out inspiration by engaging with the world around you, and don't just wait to be struck by it.

CONFIDENCE

Worried you're not very good at drawing? That's why you're learning! Remember that everybody needs to start somewhere. Your first drawings might be clumsy and misproportioned, but they are part of an ongoing process and you'll only improve by engaging with that process. If you're worried about being seen drawing, start off drawing in private and slowly build up to more public locations, or go out drawing with a friend. When you're learning, you need to make many, many bad drawings before you make any good ones, so be gentle with yourself and stick with it!

EQUIPMENT

Nothing to draw with? Make sure you're always prepared to draw, and if you're not prepared, be creative with what you have to hand. Keep your drawing materials somewhere accessible and make two drawing kits: a full bells-and-whistles drawing kit for using at home or taking to art classes, and a pick-up-and-go kit to take with you everywhere.

MAIN DRAWING KIT

Make up a main drawing kit with all of your favorite drawing materials; have plenty of your favorite paper in a folder or an art tube, with a drawing board if necessary, and a sketchbook for quick sketches and notes. Include a few items you've never used before for variety, along with extras of everything that you use regularly in case anything gets lost or broken. Get a dedicated carrying case for your materials, such as a toolbox or a robust bag.

SMALL DRAWING KIT

Get used to always carrying a small, robust sketchbook and a small pencil case containing a few pens or pencils with accompanying sharpeners and erasers. Keep it accessible so that you can whip it out for a few minutes' drawing at a moment's notice, and make sure you take it everywhere: when you go to work, when you go out for a meal, when you take the dog for a walk...

IMPROVISED DRAWING KIT

If you don't have your drawing kit with you, improvise. Make a pencil sketch on the back of a receipt, or a drawing on a napkin with a borrowed pen; draw with a stick in the sand if you have to! All you need is a surface to draw on and something to make a mark with.

Small drawing kit

Main drawing kit

Improvised drawing kit

WHAT DO I DRAW WITH?

The range of available drawing materials is vast and constantly expanding. As a starting point, here are some conventional drawing materials I will use later in the book.

Graphite

GRAPHITE

Graphite makes a smooth, gray mark with a slightly shiny surface; graphite mediums tend to make consistent linear marks. Graphite pencils are very adaptable, can be rubbed out cleanly, and give a controlled line. Pencils have different grades, measured on a scale of 9H–9B. B pencils are softer and make marks with a greater tonal range, whereas H pencils are harder and give more subtlety of tone.

Ideal for sketching

9H 8H 7H 6H 5H 4H 3H 2H H HB B 2B 3B 4B 5B 6B 7B 8B 9B

HARDER ← → *SOFTER*

Graphite sticks are similar to pencils, but are made of solid graphite and can vary in size; they often suit bolder mark-making and require less sharpening. Powdered graphite can be applied with a finger, a brush, or rolled paper to create a mass of tone quickly.

CHARCOAL

Charcoal makes a matte black mark. It has a tendency to make expressive lines of varying weight and can be used for quickly blocking in tone. Willow charcoal comes in sticks that resemble twigs; it is brittle and makes a dark, dense mark when first applied, but can be easily rubbed off a surface, leaving a lighter tone behind. Vine charcoal is usually cut into long, thin regular blocks, is often harder than willow, and comes in different grades that can be built up to make subtle tonal gradients.

Compressed charcoal is ground charcoal bound into a stick or the core of a pencil using a wax or gum binder. Compressed charcoal generally makes a harder, denser mark than regular charcoal and is more difficult to erase.

Top to bottom: Willow, vine, and compressed charcoal.

SHARPENING

Different mediums and personal preferences require different approaches to sharpening. Pencils can be sharpened with a pencil sharpener or knife, although charcoal pencil has a tendency to shatter and should be treated carefully. Snapping willow charcoal will give you a sharp edge; sandpaper can be used for sharpening charcoal and graphite. Some charcoal pencils have a paper casing and can be unwrapped rather than sharpened.

Putty and plastic erasers

ERASING

Charcoal is best erased with a putty eraser. These come in various kneads: soft, medium, and hard. The malleable eraser lifts the charcoal off the page and it often ends up black, but is still useable. Plastic erasers are ideal for erasing graphite and can be used for more precise work; try cutting plastic erasers to size with a craft knife. Think of the eraser as a drawing tool that can draw light back into dark, not just as a means of getting rid of mistakes.

SMUDGING

At its worst, smudging a mark can be a lazy and imprecise way of creating tone; at its best it can be a way of making new marks and changing the nature of existing marks. Tortillions (tightly rolled paper sticks), cloth, erasers, and fingers can all be used to smudge a mark.

FIXING

Spray-on fixative is useful for fixing your drawings to allow you to add more layers to your drawing or to avoid smudging in transit, particularly in sketchbooks where the drawing tends to imprint on the opposing page. Graphite doesn't usually need to be fixed, while charcoal almost invariably does. An artist's quality fixative is ideal, although hairspray can be a cheap (and fragrant) alternative.

WHAT DO I DRAW WITH?

PENS

Pens are inherently linear and usually give a permanent mark that can't be erased. Biros or ballpoint pens can give a surprising variety of line weight, fiber-tipped drawing pens give a consistent mark, and good quality felt-tipped pens make bold marks and come in different tones and colors. Fountain pens can be drawn with but aren't always as well suited as their cheaper counterparts. Experiment with pens that are running out of ink; the broken line can make for interesting effects.

DIP PENS

Dip pens comprised of nib and holder can create energetic and varied lines, and, despite needing to be dipped into ink periodically, they are remarkably consistent. Find a nib best suited to your purpose; calligraphic nibs aren't suited to most drawing styles, and mapping nibs can be too fine for sketching. Always clean the nib properly after use. Other materials can be cut, dipped into ink, and drawn with: bamboo, straws, sticks, feathers, and brushes. Experiment with them all to find new ways of making marks.

PAPER & SKETCHBOOKS

PAPER TYPE

Don't overlook the importance of paper; it can make as much difference to the outcome of your drawing as the material you draw with. A good quality drawing paper (cartridge paper) of an appropriate medium to heavy weight (65–145 lb., or 100–200 gsm) is suitable for most materials. Regular office paper, notebook paper, and found papers can be useful for impromptu sketching, but will generally be too light and may not last. Sugar paper and newsprint are cheap, but become brittle and discolor quickly. Experiment with different paper to find the surface you most like to draw on: draftsmen who prefer to draw on a smooth surface may like Bristol board, while those preferring a heavy texture might prefer textured watercolor paper. If you want your drawings to last, use acid-free paper to avoid the paper discoloring over time.

WEIGHT

Weight of paper is measured in pounds per ream (poundage or lb.) or in grams per square meter (gsm). Papers between 65–145 lb. (100–200 gsm) are good for drawing on. The weight of the paper will affect the feel of the mark on the page—although weight doesn't always relate to quality. Different papers will suit different preferences and mediums; do a little research into the ideal paper for your preferred drawing material.

COLOR & TONE

Bleached white paper is most common, but you might wish to try an off-white, ivory, or buff paper, as these will show off drawn marks more sympathetically and can be heightened with white. You can use colored papers, but if you do, test how the medium looks on the paper first.

DRAWING BOARDS

You'll need a flat surface to rest your paper on, ideally something you can hold at an angle and take around with you while sketching. A rigid, lightweight piece of board slightly larger than your paper is ideal; pegs, clips, or masking tape will secure your paper in place.

SKETCHBOOKS

Sketchbooks are practical and personal; they protect your paper, keep your work in order, and small sketchbooks are easy to carry around. Ring-bound books can be folded back, giving a flat plane of paper, but the bindings can break if treated roughly. Hardback sketchbooks are naturally supported; softback books can be cheap, but bend easily. Always think about the type of paper in your sketchbook, and find a size and dimension that suits your purposes. Loose paper can always be bound into a sketchbook later.

HOW DO I USE THIS BOOK?

This book is a companion along the road of learning to draw. Just like any good traveling companion, it is here to lend you support when you're on an uphill struggle and to spur you on to make drawings when you have a dip in confidence or enthusiasm, giving you straightforward, practical exercises to follow so that the only excuse not to draw every day is that you can't find your pencils (and if you cant find your pencils, reread page 9).

This book isn't even close to exhaustive. There are endless variations on drawing exercises and as many subjects to draw as there are objects in the world and ideas in your head. This book is a springboard to catapult you head first into drawing. It is a doorway into a different way of seeing the world. It is a signpost that points you on a clear route so that you feel confident to begin the journey. As you become more confident and more interested in the drawing process, you might want to take a look at Chapter 4, which explores the nature of drawing in a little more depth and can prepare you for taking your drawing practice further. Work out which of the following statements represents where you are with your drawing and use the accompanying paragraph to guide you around the book.

IF YOU'RE A COMPLETE BEGINNER, OR YOU JUST WANT TO START AT THE BEGINNING...

Whether you're completely new to drawing or you just want to go over the basics before diving in, start at Chapter 2. Even if you don't think you can draw at all. Chapter 2 is a warm-up chapter, intended to give you confidence and a few fundamental skills to build on. Once you've worked your way through First Marks, move on to Chapter 3, read the introduction to the chapter, find an exercise suitable for your location and interests, and give it a go!

IF YOU ARE COMFORTABLE DRAWING AND WANT TO GET STARTED...

If you feel confident enough to get stuck in right away, start at Chapter 3. Read the introduction and then launch in and make some drawings. This chapter contains lots of practical exercises and is broken down into locations, so all you need to do is find the location that best represents where you are, find an exercise that appeals to you, read through, and start drawing. You can adapt the exercises to other situations, as you need to. Chapter 4 will provide some interesting elements to think about when you're ready to go further, but is only really useful once you've had plenty of drawing experience.

IF YOU'RE A CONFIDENT DRAFTSMAN AND WANT TO GET INTO MORE DEPTH...

This is the point to start focusing your study. You might want to read through some of the drawing theory in Chapter 4, or you might wish to launch right into drawing with Chapter 3. Work out what it is that you want to improve on and find and adapt an exercise in Chapter 3 that suits your intentions. See the exercises as a starting point, and find ways to adapt the exercises that are relevant to you in any location. As you work though an exercise, use the To Improve section to help you relate it to the drawing theory in Chapter 4.

The more you draw, the more curious you will become about what really goes into the process of looking and mark-making. Use the final chapter of this book to go deeper into drawing with a look into the fundamental skills and concepts that lie behind the process.

EVERYBODY CAN DRAW

If you've never drawn before, or if you just want to start at the beginning, then start here. The aim of this chapter is to give you confidence and get you off on the right foot with your drawing. The exercises in this chapter each take 15 minutes or less, so all three can be done in under an hour, using basic materials. As you progress with your drawing, bear in mind the following advice.

SOME ADVICE

• There is no right or wrong way to draw, just better and worse ways of achieving certain kinds of drawings. Find and practice approaches that work for you.

• Most problems in observational drawing come from problems in looking: look first, and then draw.

• Every mark you make should be the result of a clear observation or intention, learn to make your marks with confidence.

• Learning to draw is like learning a new language, at first your drawings will be clumsy, and you'll stumble over lines as you might stumble over a foreign phrase. In time you'll learn to become more fluent and articulate in your drawing.

• As you draw you might be hampered by self-criticism. Replace your internal critic with an internal tutor by turning unhelpful self-criticism into useful questions (see page 146)

• You learn to draw by drawing. Read a bit to help you, then draw, draw, and draw some more.

• Failure is an integral part of learning; you'll make lots of bad drawings while you're learning to draw. Each "bad" drawing will be a step towards better drawings.

SETTING UP

What you need:
• A pen or pencil
• Paper or a sketchpad

Setup:
Sit down at a table and make sure you're comfortable. If you like, put on some music to relax yourself, and make sure nothing is going to distract you for a little while. You don't need any special equipment for these exercises; simply a pen or pencil and a piece of paper.

EXERCISE 1: MAKE MARKS

In order to draw better you'll want to develop a personal vocabulary of marks that you can use to make your drawings, and lines are the most fundamental element of your vocabulary. You'll want to feel confident in drawing a line, and become fluent with your mark-making: beginners often start with a hesitant, feathery line that is indistinct and slow to draw.

METHOD

Make two dots on your paper: these are your start and finish points. Without hesitation, join those dots with a single, smooth, straight line.

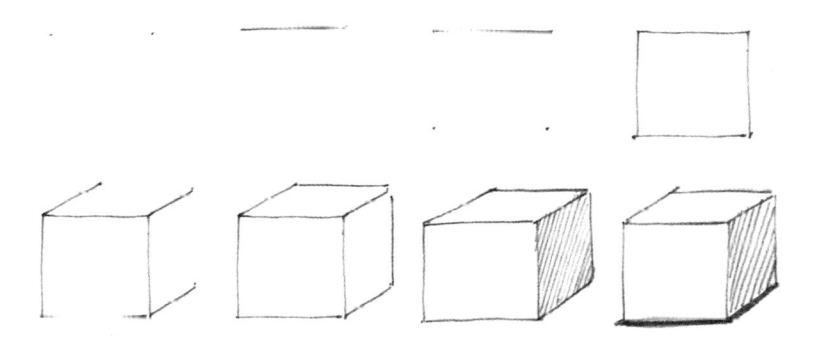

Place two more dots to make corners of a square and join those dots with confident lines to make a simple shape. Put down some more lines extending out from the square to form a cube. Draw quickly and intuitively, making each line smoothly and confidently. Now use densely packed diagonal lines to create tone, and draw over the bottom line of the cube to create a shadow.

Experiment with your lines, using different marks to join the points. Try pressing heavily at the start of a line and getting lighter to make a line with direction. Make the line wave or curve between points. Make lots of lines in parallel to cover a space in dark tone.

EXERCISE 2: DRAW YOURSELF

To make better observational drawings, you'll need to establish a strong connection between your eye and your hand. When you begin an observational drawing, you often look for edges and shapes first. Look for an edge to draw, trace that line with your eye, and then make that line smoothly and confidently on your paper with your pencil or pen. One line in isolation might look strange and abstract, but as you gather several lines together you'll start to see your subject emerging on the page.

This exercise is all about the process of looking; the outcome isn't important. First, try it with your feet as the subject, then repeat the process, now with your hand as the subject.

METHOD

Prop your feet up so that you can see them at the same time as the paper, making it easy to flick your eyes between the two. Look for edges in your shoe; trace that edge with your eye, hold the image of it in your head for a moment, and then turn it into a line on your page. Make smooth, confident lines and spend more time looking at your feet than at your drawing. Keep the drawing linear and don't try to draw everything: be selective.

First lines

Think about how all of the shapes you see fit together to make a visual jigsaw.

Start with detail first, then work out toward the larger shapes.

Shapes

Detail

EXERCISE 3: A FIGURE

When we draw familiar things, we tend to bring all of our preconceptions about that thing to our drawing. We don't always draw what we see, but instead draw what we expect to see. Learn to draw just from observation, looking and making marks in response to what you've observed, trusting your eye. Copy the upside down drawing as you see it here, working from the top corner and simply copying one line at a time. Don't think about what your subject is and don't turn your paper or sketchbook around until you are finished.

METHOD
Copy (don't trace!) the drawing on page 22 without turning the book around. Start with the outline first.

Starting in the top left corner, work your way down and to the right, looking for shapes and lines and drawing them in without trying to interpret them. When you are finished you can turn the drawing around.

START AS YOU MEAN TO GO ON

Taken at face value, each one of the exercises in this chapter is a quick and accessible way to fit drawing into your day, wherever you are and whatever you want to draw. There will often be obstacles that stand in the way of your drawing; lack of equipment, confidence, time, or subjects are the most common. Remove these obstacles and you'll find regular drawing becomes much easier.

OVERCOMING OBSTACLES
- **Don't have the right equipment?** Use page 9 to help you select your kit, and make sure you always have something to draw with close to hand.

- **Not sure what to draw?** Try out different exericises in this chapter to find out what you enjoy drawing, then look for that subject everywhere; if you like drawing people, find the people-drawing exercise in each section; if you enjoy drawing landscapes or interiors, look for the exercises that relate to those subjects instead.

- **Worried that you'll make bad drawings?** You definitely will. And some good drawings too. You never know how a drawing will come out until you've made it, and you won't make better drawings without practice. Engage with the process rather than worrying about the outcome.

- **Have trouble finding time to draw?** As long as you can identify what you want to draw and you have the materials to hand you should be able to start drawing almost immediately in any location. Make the most of your time: any gap of five minutes spent standing around waiting could be five minutes spent looking and drawing.

Each exercise is a starting point; alternatives are suggested at the end of each section along with suggestions of what you should practice to improve. Use your initiative and adapt the techniques to suit your own intentions. If you find an exercise you enjoy, try using it in a different location, or try making drawings in alternative mediums.

STYLE
Given the same subject to draw everybody will make different drawings. Don't worry about establishing your own "style" of drawing. Style is a nebulous concept comprising elements of the materials you draw with, how you perceive your subjects, and your physical application of marks. By all means learn from other artists, but don't try to be them; learn to borrow elements from their drawings to assimilate into your own practice. Learning to draw is a journey of self-discovery, experimentation, and innovation, and it takes a long time to learn to draw like yourself.

TECHNIQUES & ATTITUDES

Techniques are structured processes, developed to help you arrive at particular outcomes. A drawing technique is like a recipe and, just like cooking up a new dish, you can make a particular kind of drawing by following the appropriate technique to achieve the desired outcome. As with cooking, sometimes it will work, sometimes it won't, and practice will help you to improve. Any technique that you learn should be seasoned to your taste to make it your own. Over time, you will develop your own techniques that incorporate the variety of approaches you've learned in the past to create outcomes that are unique to you.

More important than the techniques you employ is the attitude you take to your drawing. Sometimes you are happy with a drawing, sometimes you are not; rather than defining your success by your outcomes, aim to maintain integrity in your process. Make drawings that are authentically your own, driven by curiosity and intention, and you will gain something from the process irrespective of the outcome. A drawing you are happy with gives you satisfaction and a drawing you are not happy with gives you a learning opportunity; both are important and valuable.

VARYING YOUR MATERIALS

For each of the following exercises I have recommended a drawing medium that is appropriate to the location and task; if the exercise requires tonal drawing, for example, then I have suggested using charcoal rather than, say, a ballpoint pen, which might better suit a linear drawing exercise. All exercises could be attempted in other media so don't feel you are restricted just to the materials suggested, simply think about to how changing your drawing material might create a different kind of outcome or necessitate an altered process. Experiment, explore, and enjoy using your materials!

MAKING DRAWINGS
AT HOME

Sketching at home will give you lots of control over your surroundings: you'll be able to set yourself up comfortably, with drawing materials to hand, and you'll be able to keep this book at your side to guide you through the exercises. Beware though; it is easy to be waylaid by the responsibilities of domestic life, so set aside dedicated time to draw and do your best not to get distracted!

ACCESSIBLE KIT

First, make sure your drawing materials are easy to find. Store your main drawing kit (see page 9) somewhere accessible so that you don't waste time searching for the disparate contents of your art box. Maintain a stock of your favorite drawing materials alongside your primary kit so that you don't run out: if you like drawing with ballpoint pens then don't just buy one but have several packs dotted around. If you like working in pencil, buy a whole load of erasers and sharpeners, and have them both with your kit and near to anywhere you might be drawing. Keep a small sketchbook and drawing materials in a kitchen drawer so that you can draw while the kettle boils, or on a coffee table for making swift studies of your family watching TV on the sofa.

PORTRAITS

We are inexorably drawn to other people's faces; many of us start drawing in the hope that one day we can accurately and empathically render the face of another person on paper. We have evolved to recognize the subtle plays of expression on another person's face and to recognize the minute proportional differences that differentiate us from one another. It is this very faculty of recognition that both allows us to make empathic portraits of one another while also making us critical of the drawings we might create. The human face is the most challenging subject available to you; if you can learn to draw a face you can learn to draw anything.

Sitting down with somebody to draw them can be a wonderful opportunity to look at them in a way you may never have looked at them before. Make sure your sitter has realistic expectations of the outcome, be honest with them about your level of experience, and allow yourself time to make more than one drawing. A time limit of 15–20 minutes per drawing is ideal for most people to sit before they start fidgeting. Ask your model to get comfortable and to set their eyes on a fixed point. Don't be afraid to guide them into a suitable pose and to ask them to return to it if they move; they'll thank you later for anything that helps you make a better drawing!

SETTING UP

What you need:
- Pencil
- Eraser
- Sharpener
- Drawing board and paper

Time:
Allow an hour for the sitting, with poses of 15–20 minutes

Setup:
Think about how the light will fall on your model's face and your paper. Let them get comfortable and place yourself so that you have the head angle you prefer. A profile will give you a clean line to work with; a head-on view will provide symmetry and directness; a three-quarter view can be challenging but dynamic.

AIMS & ATTITUDES
You should approach this portrait as an exercise in looking. Draw the overall mass of the head as well as the face itself. Represent the shapes of any shadows you see, rather than worrying about how you think a face should look. Your idea of how a face should look often stops you making clear observations of what you see in front of you; the purpose of this exercise is to simply draw what you see.

PORTRAITS

METHOD

Start with the mass of the head and imagine the shape of the skull underneath. Loosely sketch the oval of the cranium, the jaw, and the average line of the front of the face, followed by the mass of the neck.

Sketch in the shape of the eyebrow, work down to the dark shape of the eyelash and iris, the underside of the nose, the centerline of the mouth, and the overall shape of the ear.

Elaborate on the lines of the face, using the marker points of the features to guide you. Find the overall shape of the hair on the head and block in the tone of the hair using marks that follow the direction of the hair.

--

ALSO TRY...

Making studies from different angles to understand the shape of the whole head. Try drawing people in profile while they're in front of the TV or computer.

TO IMPROVE...

- Spend more time drawing heads (pages 46 and 68).
- Learn about the anatomy of the skull (page 172).
- Learn more about the edges of the profile (page 148).
- Learn more about relationships between features (page 150).

DRAWING ROOMS

If you find yourself sitting in the corner of a room at home, pencil and sketchbook out, wracking your brain for what to draw, then don't despair: the solution is all around you! This is a great exercise to try in your home, but it can easily be applied anywhere. You can apply the same approach to drawing in any enclosed space: waiting rooms, airports, offices, or anywhere you find yourself with a few minutes to spare. It can be a great way of recording the places you have visited and rooms you've stayed in, or of recording a single space changing over time.

SETTING UP

What you need:
• Ballpoint pen
• Sketchbook

Time:
20 minutes.

Setup:
Sit comfortably, with a good view of the whole room.

AIMS & ATTITUDES

This exercise is all about taking your eye on a journey around the room and recording that journey on your paper. Don't be concerned about the strictures of proportion or perspective; simply aim to draw shapes in the appropriate relationships to one another.

DRAWING ROOMS

METHOD

Decide on an area of detail somewhere in the room where you will begin your drawing. Take your eye around the outlines of the objects you are drawing and use a simple, continuous line to record the shapes that you see. Keep the drawing linear, leaving out tone. By working out from a little pool of detail on the page, you make it easy to return to the drawing if you get called away.

Work outward, following key lines around the room. Don't try to be too accurate, but draw from what you see. Lift your pen from the paper when you need to; if a line goes in a place you don't want it to, leave it where it is and re-draw it elsewhere.

Work the drawing right out to the edges of the page; you are bound to have fallen out of proportion at some point, but don't worry. See this as an exercise in looking rather than as an exercise in making an accurate picture.

ALSO TRY...
As a variation on this exercise, try making the drawing without looking back at your paper. See more instructions on this kind of "blind" drawing on page 104.

TO IMPROVE...
- Learn to use your pen to judge proportions and angles (page 151).
- Develop your understanding of edges (page 148).
- Develop your understanding of shape (page 152).

MAKING STILL LIFE EXCITING

Inanimate objects make the most reliable and consistent subjects. You can pose them as you like and draw them without their needing to stretch, or wandering away when they need something to eat. The problem with drawing still-life objects is finding a subject that holds your attention. It is always important that your subject engages you; you should only draw things you really want to draw otherwise you'll bore yourself, and your drawing will lose its sense of purpose. It is a skill in itself to learn to find something interesting in any subject.

For this exercise, pick an object that has meaning to you as your main subject. Find a second object of meaning with a contrasting nature, something with different textures, or of a different size, and imagine a simple narrative that ties the objects together. Place them near to one another to make a visually satisfying composition. Finally, place a third object to set the other two off. Give yourself a reason to make the drawing; make it interesting.

AIMS & ATTITUDES

You're aiming to select interesting objects and to create a composition out of them. Look for the shapes of shadows in the arrangement, and explore how you can create the illusion of three dimensions through simple blocks of tone, using the eraser as a drawing tool and using the charcoal pencil to add clarity to shapes.

SETTING UP

What you need:

- Charcoal stick
- Charcoal pencil
- Cloth or kitchen roll
- Eraser
- Paper and board
- Three objects
- A desk lamp

Time:

45 minutes.

Setup:

Set yourself up comfortably in front of your subject. Arrange the objects as you'd like them, but don't over think their composition. Set them up near a window or lamp so that the directional light creates clear shapes of shadow.

MAKING STILL LIFE EXCITING

METHOD
Scrub a ground of charcoal onto the paper to establish a pale gray mid-tone. Using the stick of charcoal, draw the outline of shadow and object shapes. Look for big shapes first.

Use the eraser to draw light into the image, and a snapped charcoal stick to draw in blocks of dark. Build up tonal contrasts.

Use the eraser to erase back to the white of the paper for the lightest lights, and use the charcoal pencil to build up the darkest darks, adding textural marks to the drawing.

ALSO TRY...

Exploring the still life from unusual angles. Make quick studies of it from the opposite side, from the top, or from the floor. Note how the shapes change and the feel of the picture shifts when drawn from different viewpoints.

TO IMPROVE...

- Learn about negative space (page 112).
- Learn to see tone more clearly (page 154).
- Learn more about composition (page 158).

DRAWING ANIMALS

Pets have as much character as their human counterparts and make engaging subjects to draw. However, the inevitable language barrier means that it is unlikely they'll understand you asking them to pose for a long drawing. You can draw a surprising amount in the moments that they are still, making for energetic albeit incomplete drawings. Think of this kind of dynamic drawing as a record of your interaction with the animal, and for maximum drawing time, try to catch them at moments when they are still. Draw your dog while it is eating, or your cat while sleeping; a fish in a tank might repeat a movement, giving you an opportunity to finish partially complete drawings. Drawing from photographs will allow you to capture the look of your animal but it won't allow you to capture the feel of their movement; enjoy the experience of drawing a moving target!

SETTING UP

What you need:
- Dip pen
- Ink
- Paper
- A pet to draw

Time:
25 minutes.

Setup:
Use a portable sketchbook or board so that you can follow your subject, taking every opportunity to make quick sketches.

AIMS & ATTITUDES
This is as much a philosophical exercise as a practical one. Due to the hit-and-miss nature of the task, you will have some successful drawings and many that don't work at all. You almost certainly won't finish any of them; see the drawings as recording an experience, not just making pictures.

DRAWING ANIMALS

METHOD

Watch your subject for a while
and work out when they are
most likely to be still.

Sketch the overall form
of the animal, looking for
simple geometric shapes
beneath the fur. Look for
repeated shapes when
your animal moves; you'll
find they often return to
poses, allowing you to
continue the drawings
you've started.

Fur and markings
can be layered over
the structure of a pose,
and can be ascertained
from a variety of different
poses. Practice different
kinds of mark-making
to render textures.

ALSO TRY...

Taking your sketchbook to a
zoo, a farm, or an aquarium.
If you want animals that will
reliably stay still, you can try
sketching at a museum of
natural history.

TO IMPROVE...

- Improve your visual memory
 by sketching people moving
 (pages 46 and 62).
- Practice intuitive, gestural
 drawing (page 108).
- Learn to see edges
 more clearly and to draw
 confident lines (page 148).

OUT & ABOUT

Even when you don't have a pencil to draw with, you can practice looking around you with the eyes of a draftsman. Be curious, and look for line, shape, and tone in the world around you. Try to have materials with you at all times so that when opportunities to sketch your observations present themselves, you can the make the most of them. Carry a sketchbook and drawing materials everywhere and improvise if necessary, drawing on scraps of paper that can be stuck into your sketchbook later, for example. Don't worry about passersby watching you while you draw; talk to people about your drawings, or, if you're shy, go drawing with a friend and make a social occasion of it. Drawing can be an excellent way to record new experiences and to find new wonder in everyday things.

EXERCISE: **PASSENGER PORTRAITS**

What you need:
• Ballpoint pen
• Sketchbook

Time:
As long as your journey!

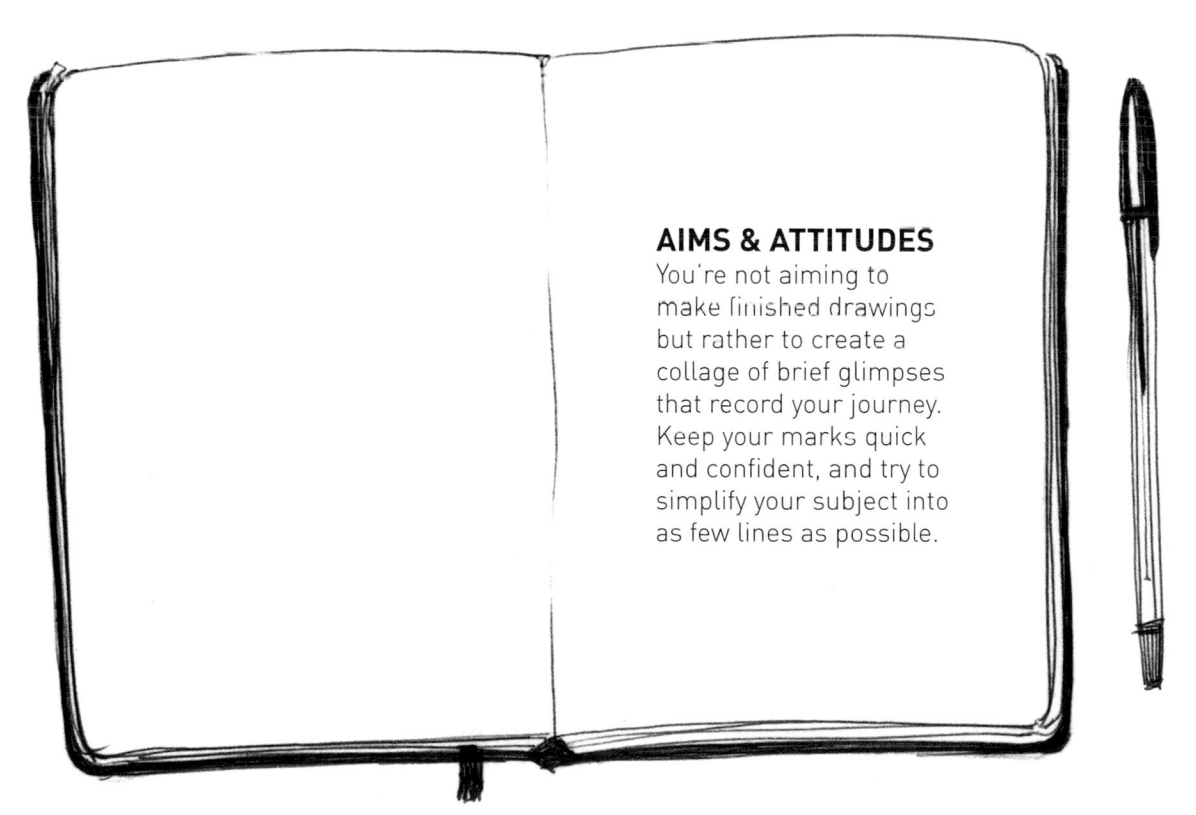

AIMS & ATTITUDES

You're not aiming to make finished drawings but rather to create a collage of brief glimpses that record your journey. Keep your marks quick and confident, and try to simplify your subject into as few lines as possible.

SKETCHING ON PUBLIC TRANSPORT

METHOD

Pick a person who is staying relatively still and (ideally) not looking toward you. Using quick, simple marks, sketch out the dark lines that make up your impression of their face.

Work outward on the page using simple lines to suggest the basic forms of your subject's clothing and surroundings.In this exercise your pen will be recording the journey that your eye is taking over your subject.

" my neighbour
always gives me books abt psychopaths "

When your subject moves,
try sketching this new angle,
or move on to somebody else.
Fill the page with little visual
notes on the journey, snatches
of conversation, and anything
that interests you.

ALSO TRY...
Filling a page with things
you see outside the window,
making it into a dynamic
composition of signs,
textures, buildings, and
briefly glimpsed views.

TO IMPROVE...
• Practice drawing faces
 (page 28).
• Practice linear drawing
 and interiors (page 32).
• Try blind contour drawing
 (page 104).

number 17 bus route to Enfield

URBAN SKETCHING

The urban environment is the result of thousands of drawings; town planners, architects, and designers conspire to create the jigsaw puzzle of buildings and public spaces that make up a city. Each city has its own character, its own combinations of buildings shapes, colors, and textures. Its inhabitants shape it even more, filling the streets with stories. When you make drawings of urban spaces, you're not just sketching bricks and mortar; you're making a portrait of a city. This exercise is all about capturing corners of the town or city around you; bring little figures into the scene using the exercise on page 62, and make written notes wherever you need to.

EXERCISE:

AN URBAN PORTRAIT

What you need:
- Ballpoint pen
- Gray felt tip
- Sketchbook

Time:
20–45 minutes.

AIMS & ATTITUDES
This approach is an alternative to the drawing rooms exercise on page 32. Rather than working from small shapes and expanding, you will establish large shapes first and then draw the smaller areas of details within them, allowing you to maintain control over the composition. As well as capturing how the city looks you should aim to capture something of its atmosphere, looking for characterful details to accentuate.

URBAN SKETCHING

METHOD
Establish the overall composition of the scene, thinking about where you will place buildings. Start with a light line to establish shapes, and draw over with a more confident line when you have decided where the emphasis will lie.

Draw into the composition any interesting details and elements that catch your eye. Again, work lightly and confidently, drawing bolder lines over your initial marks once you are confident of their position.

Use the gray felt tip to add simple blocks of tone, adding depth and focus to the scene. Be selective with where you place the tone, thinking about the design of your drawing.

Flower stall, North Laine

ALSO TRY...
Adding color to your drawing using colored felt tip, or watercolor washes in place of the gray pen.

TO IMPROVE...
- Improve your understanding of how to compose a scene (page 164).
- Learn more about seeing edges (page 148).
- Learn more about using tone and color (pages 154 and 168).

RURAL LANDSCAPES

Landscape drawing shouldn't just be about sketching picturesque scenery; it should be a record of the experience of drawing in the landscape. The urgency of your marks will inherently reflect your relationship to the environment around you. Drawing on a windy day creates frantic drawings as you scrabble to keep the paper under control; a lazy summer afternoon on the grass tends to produce more leisurely strokes. You'll be using drawn marks to represent the visual phenomena of the landscape, while being inevitably affected by the elemental forces around you. As you draw different parts of the landscape explore how you can use a variety of marks to imply texture or direction of surfaces and think about how you can draw attention to elements of the landscape that interest you. Get out and about; make drawing an adventure, and don't just rely on your photographs.

EXERCISE: **SKETCHING IN THE LANDSCAPE**

What you need:
- Pencils
- Eraser
- Sharpener
- Sketchbook

Time:
Draw until you're too hot, cold, or too uncomfortable to draw any more!

Setup:
Find somewhere comfortable to perch with you sketchbook or drawing board. You might have the luxury of drawing from a window, although there's nothing better than being right in the middle of the scenery.

AIMS & ATTITUDES
This exercise is intended to help you look at the landscape around you and to experience it through drawing. It's also a great opportunity to practice your composition and to explore varied mark-making.

RURAL LANDSCAPES

METHOD

Pick your view carefully and establish the major lines and shapes of the composition that you see in front of you. Think in terms of tonal masses as you decide your composition.

Block in the masses of tone in the scene, breaking it down into foreground, midground, and background. Unfocusing your eyes a little will help you to judge relative tones; note how the background often appears tonally lighter than the foreground.

Work more detail into your scene, using textural mark-making to create visual variety in the scene and focus the attention of the viewer. Focus more on foreground details, letting the background remain vague to create the illusion of depth.

ALSO TRY...

Splitting a page into boxes and trying out some tiny simplified thumbnail studies to provide you with alternative views, or a visual narrative of a walk.

TO IMPROVE...

- Learn more about composing your image (page 164).
- Develop your understanding of tone (page 154).
- Learn more about using shapes of tone in your drawing (page 152).

DRAWING TREES

From sprightly saplings to bowed grandfathers of the forest, there is an anthropomorphic quality to trees that makes them an engaging subject for drawing. As with a figure, you can attempt to capture the complete pose of a tree, making drawings that generalize details to capture shape and form, or you could choose to study discrete parts, making small drawings of braches, leaves, and fruits. This exercise is about capturing the feel of a tree energetically and efficiently; the figure drawing exercises on page 102 could also be applied to drawing trees.

EXERCISE: **FOREST DRAWING**

What you need:
• HB Pencil
• Dip pen
• Ink
• Sketchbook

Time:
One hour or more.

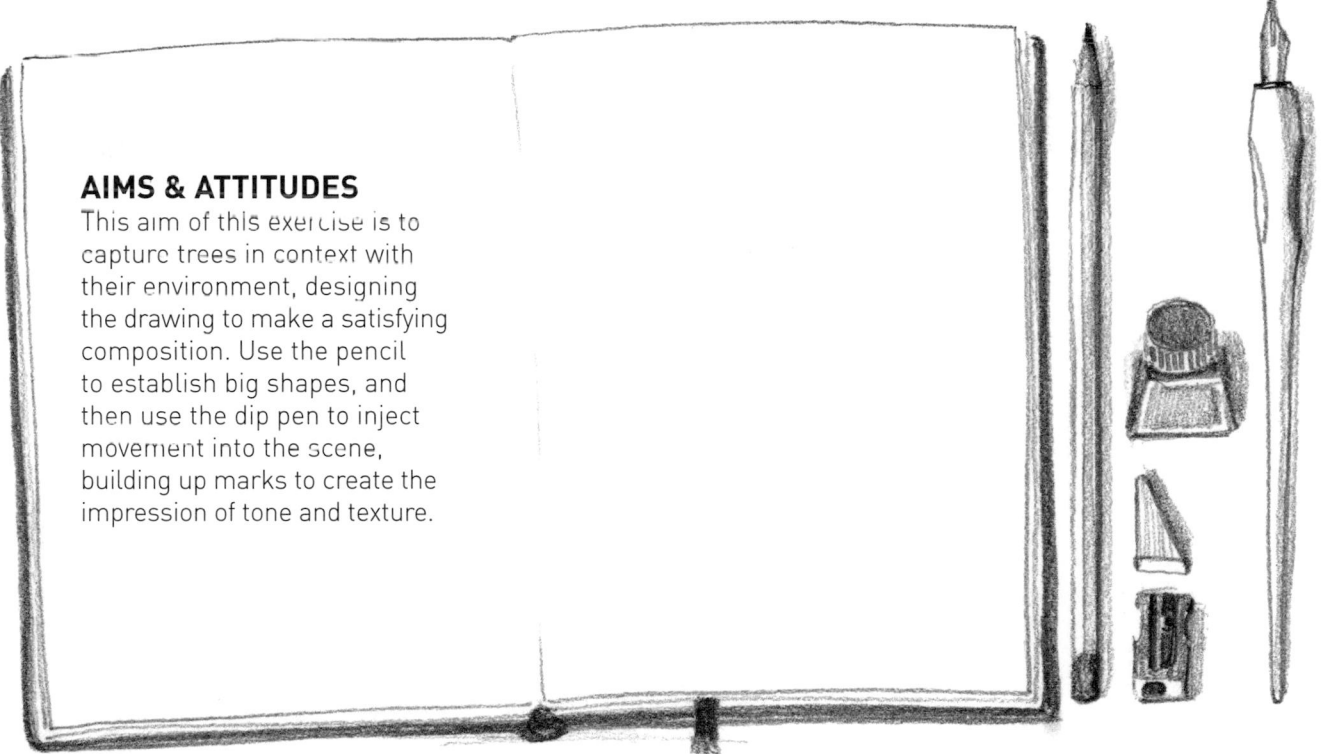

AIMS & ATTITUDES

This aim of this exercise is to capture trees in context with their environment, designing the drawing to make a satisfying composition. Use the pencil to establish big shapes, and then use the dip pen to inject movement into the scene, building up marks to create the impression of tone and texture.

DRAWING TREES

METHOD
Establish the form of the trees in pencil. Don't get caught up in detail, but record their overall shape.

Draw in more details, working from big shapes to smaller shapes, and drawing the negative spaces between the branches.

Draw over the pencil with energetic textural marks in ink; don't draw what you imagine a tree should look like, but draw the shapes of branches, bark, and leaves that you see in front of you.

ALSO TRY...

Making similar studies of plants and flowers. Take a look at examples of botanical drawing and go out in search of beautiful blooms to draw!

TO IMPROVE...

- Learn more about negative space (page 112).
- Learn to judge relative tones (page 154).
- Learn to make balanced compositions (page 164).

LITTLE FIGURES

The human form can seem like a complex subject to tackle, but it needn't be intimidating. The figures that populate the cities and rural landscapes that we might draw can be seen as tiny collections of simple shapes that give the suggestion of humanity. By drawing the figure as simple blocks of tone, leaving out any detail, you can tap into the shapes of clothing and gestures. This exercise is intended for quickly sketching static or moving people at a distance, and can be combined with previous exercises to add figures to your urban and rural landscape drawings.

EXERCISE: **DRAWING PEOPLE**

What you need:
- Pencils (2B, 4B)
- Sketchbook

Time:
1–3 minutes per figure.

AIMS & ATTITUDES
This exercise is mostly about simplifying something you know to be complicated into the simple shapes that you actually see in front of you. Draw small, and try to perceive the figure as a whole shape, made up of smaller shapes of clothing. As you observe them, hold the shapes of movements in your head like frames of a film, helping you to develop your visual memory.

LITTLE FIGURES

METHOD

Draw the figures no bigger than your little finger. Work from the inside out, using short marks to sketch in the mass of tone that makes up the torso and head, treating them as simple blocks.

Use simple, directional tonal mark-making to block in the shapes of arms, legs, and clothing, arriving at a simple silhouette of the figure.

Use darker tonal mark-making to create focus, drawing the darker shadows that you see, avoiding drawing anything you can't clearly see. You can use an eraser to clean up the edges of the tonal shapes.

ALSO TRY...
Putting together figures you've sketched out and about and environments you've drawn to compose imaginary scenes. This will develop your imaginative drawing skills at the same time as borrowing usefully from your observations.

TO IMPROVE...
• Work on your visual memory (page 144).
• Develop your tonal mark-making (page 154).
• Learn to judge shapes better (page 152).
• Practice gestural figure drawing (page 108).

AT MUSEUMS & GALLERIES

Museums are incredible resources, repositories of history that give us insight into the world around us. As a sketching location, even the lowliest museum will house sufficient curiosities to keep you scribbling for hours; national museums can be a source of wonder for a lifetime. By drawing with friends and family you can engage with exhibits in a new way, looking harder than you might have ever looked in the past.

Walking around art galleries with a draftsman's eye will give you a new way of relating to the work you see. The ability to see critically is a hard-won skill, and some artwork requires time to be properly understood and appreciated; you don't have to like the work you see to learn from it. Drawing from artwork will help you gain insight into the processes of the artist who created it.

Most museums and galleries welcome sketchers; some even provide fold-up chairs to carry around with you. If you're visiting a museum or gallery with non-drawers then prepare to be left behind each time you get caught up in a sketch.

IDEAL KIT

You'll need easily portable drawing materials that won't make a mess, so avoid charcoal sticks and pots of ink. Keep to pens and pencils, and use sharpeners with an attached container for catching shavings. A compact sketchbook will be ideal to draw in, or you could bring a drawing board and paper in a folder.

CAST DRAWING

Many galleries contain busts; head-and-shoulder portrait sculptures usually carved in stone or cast in metal. Light colored stone or plaster busts will provide you with a great opportunity to study surface tones without the complication of varied skin color. Cast drawing is often associated with the sight-sized studies (where the drawing is made the same size as the subject appears from wherever the artist is standing) popular in contemporary drawing ateliers; in contrast, this version of the activity is a practical guerilla-drawing exercise that will yield loosely defined sketches of your subject. Drawing busts allows you to sketch a considered portrait from a perfectly still and consistently lit model. If you're looking for portrait drawing practice, this will be superior to copying from photographs as it will incorporate all the challenges of translating a three-dimensional head into a two-dimensional drawing without the performance anxiety of working with a live model.

EXERCISE:

DRAWING FROM A BUST

What you need:
- Pencil
- Eraser
- Sharpener
- Sketchbook

Time:
20 minutes.

AIMS & ATTITUDES
As you set up to draw, think carefully about the angle and lighting of the head—although you can't move the bust, you can control your own position. The outcome of your drawing will be led by your initial decisions as much as by your drawn marks. Taking a different attitude to the bust will create different drawings: drawing the bust while imagining it to be a real person will allow you to imbue the drawing with the vitality of a living sitter. In contrast, drawing the bust as a still-life object will encourage more accurate and objective drawing.

CAST DRAWING

METHOD

Choose your position; think about the head angle, the lighting, and how the drawing will be composed on your page. Start with a loosely sketched outline, jotting in the top, bottom, left, and right limits of the head with short, sharp marks.

Don't become fixated on features, but instead draw the edges of shapes of shadow. The resulting jigsaw of tonal shapes should resolve itself into the illusion of a face.

Add tone to the shapes of shadow. Keep your mark-making simple and consistent and reduce complicated gradients of shadow into simple blocks of mid-tone. Don't go too dark too quickly but reserve your darkest marks for the deepest edges of shadow.

ALSO TRY...

Drawing from garden statues; if you don't have ready access to a gallery with busts, try sketching in garden centers and public parks, or buy yourself a plaster cast or stone garden ornament to draw from.

TO IMPROVE...

- Practice alternative approaches to drawing heads (pages 28 and 46).
- Learn more about shape and tone (pages 152 and 154).
- Develop practical measuring techniques (page 150).

INTELLIGENT TRANSCRIPTIONS

We can all intuitively appreciate paintings, prints, and drawings on a visual and emotional level, and accompanying text, gallery staff, and audio tours might provide details of the historical and cultural context of an artwork, or the motivations behind its creation. As a maker of drawings, you might also want to gain greater insight into an artwork by making focused studies that interrogate its composition and execution, learning lessons from the work that you can apply to your own.

In order to gain the most from your transcriptions you'll need to draw with clear intention and avoid simply re-drawing imagery in your own style. Copy drawings in order to learn something about the artist's mark-making; as you draw don't simply replicate the drawn marks, but ask yourself questions about how the artist made them: What medium have they used? How did they hold that medium? How far were they from the paper as they drew? Were their marks made slowly or quickly? Are they loosely drawn or tightly controlled?

Paintings and drawings can be reduced to their fundamental compositions by an understanding of their armatures and use of tone. If you are trying to copy paintings and non-drawn artwork by drawing them, you won't learn nearly as much as you might by making focused transcriptions.

EXERCISE: **TRANSCRIPTIONS**

What you need:
• Pencil
• Eraser
• Sharpener
• Sketchbook

Time:
Spend plenty of time looking at the work, and then spend 15 minutes making each transcription.

AIMS & ATTITUDES
Make transcriptions from artworks in order to understand them better. You can make different transcriptions to learn different lessons from a work: try developing your own approaches to transcription.

INTELLIGENT TRANSCRIPTIONS

METHOD

First, take a look at page 164 for guidance on composition. For this exercise you'll want to look for the basic compositional devices that underpin the image, and to appreciate how the dimensions of the picture plane affect its appearance.

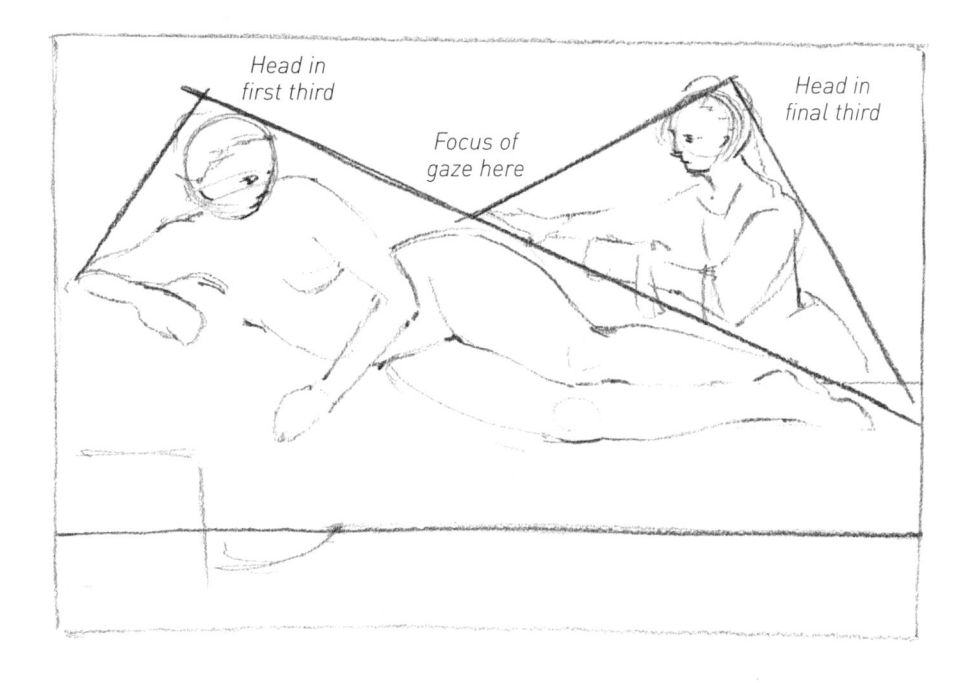

Head in first third

Focus of gaze here

Head in final third

To develop your understanding of a composition, you can transcribe for tone by simplifying the picture into blocks of light and dark. Take a look at page 154 to gain some further insight into tonal drawing.

Make a copy of a section of another artist's drawing, think about what elements of their subject they have chosen to represent and try to emulate their marks and to learn how they make them.

TO IMPROVE...

- Learn more about composition (page 164).
- Learn more about shape and tone (pages 152 and 154).
- Explore mark-making (page 18).
- Regularly visit art exhibitions; don't just look at images of artwork online.

STEAL LIKE AN ARTIST

This exercise will involve using the transcriptions from page 72 as a means of gathering information that can then be applied to your own, original drawings. The compositions and mark-making that you choose to borrow needn't just be applied to the subject represented in the original drawing. For example you could take a composition from a landscape painting and apply it to a still-life drawing, or apply the marks from an artist's drawing of a tree to your own study of a figure.

EXERCISE: **BORROWED MARKS**

What you need:
- Pencil
- Eraser
- Sharpener
- Sketchbook

Time:
Variable

AIMS & ATTITUDES
Bear in mind that you are drawing in order to learn. By emulating a great artist whose work you admire, you should be learning from their approach and applying those lessons to your own work; you might discard some approaches over time while assimilating others into your regular practice.

STEAL LIKE AN ARTIST

METHOD

In this example I have taken the composition of a landscape painting and applied it to a still-life drawing, using a variation of the exercises on page 36.

Transcription of an Ian Roberts landscape

Simplification of the landscape

Still life based on the landscape

Finished still-life study

Giorgio Morandi still life

Tonal simplification

Drawing of a group scene

Here, I've taken the tonal distribution and composition from a still life and used it to develop a group scene, taking figures from my sketchbook, borrowed from the alternative exercise on page 62.

In the bottom drawing I have borrowed the marks I observed in a figure study and applied them to a drawing of a tree from the exercise on page 58.

TO IMPROVE...
- Make more transcriptions to develop your artistic vocabulary.
- Try making drawings in the style of artists you admire in order to learn more about their techniques.
- Apply the lessons learned from transcriptions to different exercises in this book.

SKETCHBOOK OF CURIOSITIES

As you wander around a museum there will always be little artifacts, trinkets, and ephemera that catch your eye. Taking the pieces home yourself is broadly frowned upon, so try collecting them in your sketchbook by making little drawings of them all. Make your sketchbook into your own personal collection of curiosities, composing them together on the page and adding your own annotations and reflections.

EXERCISE: **SKETCHBOOK OF CURIOSITIES**

What you need:
- Pencils
- Sharpener
- Eraser
- Sketchbook

Time:
A single drawing might take 5–20 minutes.

AIMS & ATTITUDES
Become a collector of little pictures of things. The items you choose to draw will say something about where you are, who you are, and what interests you. Filling a page might be a full day's work, and filling a sketchbook might take a month, or a year, or a lifetime. Each small drawing is a contribution to a greater whole.

SKETCHBOOK OF CURIOSITIES

METHOD
Set a scale for your sketches; you might want to draw the items in correct proportion to one another, or to play around with scale. Each time you add an item, think about where you will place it on the page.

Make simple sketches, drawing the shapes of objects, dwelling on the elements of the subject that interest you and making any notes you feel add to the drawing.

Fill the page with objects, composing them as a collector might line up items in a display case. Date your drawings for posterity.

ALSO TRY...
Making sketches of other collections of items that interest you, from discarded items in the street, to objects from your house. Set items next to one another in interesting ways, making the mundane intriguing.

TO IMPROVE...
- Think about how you compose the items on the page (page 164).
- Develop your core drawing skills (Page 146).
- Practice observational drawing exercises to help you improve your looking.

MAKING DRAWINGS
AT WORK

Drawing is a visual language, a tool for communication. When we draw for artistic purposes, we use this language poetically, employing marks that describe our subject with eloquence and grace. Like any language, drawing can also be used to record ideas, to describe concepts, and solve problems. If you want to draw more, then don't confine drawing to your leisure time; start using visual language in your work. This chapter contains practical applications for drawing in the workplace, with exercises that you can try outside of work in order to develop your skills.

APPLICATIONS OF DRAWING

- **Draw to communicate.** Drawing breaks down language barriers and is often the best way to describe complex visual or spatial subjects. You might draw a map rather than give spoken directions, for example.

- **Draw your ideas.** Drawing can be a way of exploring new ideas and articulating things that you don't quite have words for. Most man-made objects start life as a drawn design.

- **Draw to remember.** A drawing can act as a helpful mnemonic; an illustrated story is more memorable than a purely verbal one. Images can conjure instant associations; this is why a company might have a picture as a logo.

- **Draw to get a new perspective on a problem.** The process of drawing allows you to look at the world in a fresh way, by drawing something you often learn to understand it better.

PRACTICAL ADVICE

- **Don't let performance anxiety hold you back.** Practice your drawing at home and bring the skills you learn to work.

- **Start to think of drawing as part of your arsenal everyday communicative tools.** When you need to describe something, think, "Could I draw that instead?"

- **Use your breaks for practice.** Try some of the other drawing exercises in this book during lunch (try the exercises from pages 32, 46, and 130).

- **Recognize how you might already be drawing, and develop your skills to enable you to do it better.** Diagrams, doodles, and maps all employ drawn marks.

- **Find colleagues that want to learn to draw.** Sketch at work together, start a sketchcrawl, or go to a life-drawing class after work.

- **Bring in expertise.** If you think your colleagues would benefit from better visual communication skills, consider inviting a drawing tutor in to run a workshop.

IDEAL KIT

Practical, communicative drawings require materials that make clear, efficient marks. Pens, pencils, and good-quality felt-tip pens are good materials to start with. If you need to draw on a white board or flip chart think about how you'll stand in order to minimize the distortion in you drawing All the drawings in this chapter utilize the same set of materials:

- Felt-tip pens
- Ballpoint pens
- Fineliners
- Pencil
- Eraser
- Sharpener
- Paper

SEQUENTIAL NARRATIVE

Images arranged in an order create a linear, visual story. These sequential images are often used for instructions as they can be easily imitated. Signage is the simplest kind of instructional imagery; the little person running toward the door on a fire exit sign immediately conveys what to do in the event of a fire. Instruction manuals often contain simple annotated line drawings to demonstrate how to assemble a model plane, or how to use your oven. A multi-panel instructional drawing needs to be unambiguously drawn, using simple, efficient marks, illustrating the key stages of the activity it describes. For the exercise on the next page you will make a simple instructional drawing for fun, illustrating a day-to-day task. The aim is to be efficient and use as few panels as possible, while illustrating each separate action required for the task and stripping out all unnecessary detail. Enact the activity yourself, taking photographs to draw from, or drawing from your imagination (see page 144). Use other pages in this book to help you improve your drawings of specific activities or locations.

EXERCISE: **INSTRUCTIONAL DRAWING**

Applications

- Leaving instructions for family or friends at home
- Leaving instructions at work
- Signage, as simplified instructions

SEQUENTIAL NARRATIVE

METHOD

Pick a task to illustrate, break it down into five simple actions, and using a pencil loosely plan out panels that illustrate each stage in the simplest way. As you plan the task, you might want to describe it verbally to help you break down the stages.

Take a photograph of each stage of the task and make a simple pencil line drawing based on each one. If it involves hands, you might want to refer to page 130; figures, page 98; or faces, page 138.

Go over the pencil lines in pen, clarifying
the shapes. You might want add simple tone
or color to the drawing using felt-tip pen.

ALSO TRY...
Drawing a simple
storyboard. The storyboard
is a standard device used
to tell a linear narrative
in key frames of action.
Animators and filmmakers
might use storyboards to
plan out scenes.

TO IMPROVE...
• Practice simple line
 drawings (page 32
 and 46).
• Practice simple figures
 (page 98).
• Practice sketching
 the subjects of your
 instructional drawing
 from observation.

DRAWING FOR DESIGN

Verbal language tends to fix ideas to existing concepts, but when you're designing something new you might want your ideas to remain pliable as you develop them. Drawing allows you to explore a visual idea without pinning it down so that you can trial alternatives and develop your thoughts. Presenting your ideas as drawings makes it easy for other people to engage with a new idea and to see the process you followed to arrive at your final outcome. If you're designing something new, you might first want to use observational drawing to explore other approaches to the same subject, as well as drawing shapes and objects that inspire your own designs. This exercise will help you try out the approach by designing an imaginary new chair, breaking the process down into idea-gathering, trialing new ideas, and refining your favored design. This is a basic approach to design; professional product designers, concept artists, architects, and so on, will all have their own design processes, and in time you will doubtless develop your own.

EXERCISE: **EXPLORING AN IDEA**

Applications

- Designing new objects you'd like to make: cupboards, candlesticks, etc.
- Working out the best way to do a practical task such as putting up a shelf—planning its position on the wall, the brackets you will use, what to put on it, etc.
- Planning the look of something, for example an outfit, party decorations, etc.

DRAWING FOR DESIGN

METHOD

Gather ideas. Make observational drawings of chairs and any object that might provide further inspiration. Explore the practical purpose of the chair and extract shapes and textures from inspirational material.

Sketch a variety of alternative chair designs from your imagination, giving yourself several options to work from. What would you like to see in a chair?

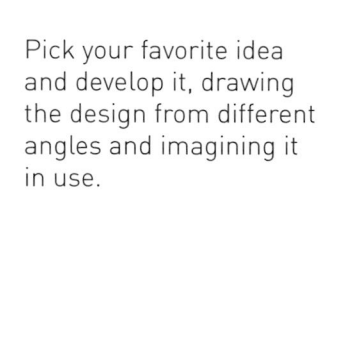

Pick your favorite idea and develop it, drawing the design from different angles and imagining it in use.

ALSO TRY...

Costume design. Use the stickman on page 98 to create a standard figure from the front and side and try out different costume designs. Fashion design uses a stylized, attenuated figure; character design might require a greater variety of figure shapes.

TO IMPROVE...

- Make more sketches from observation.
- Learn to extrapolate lines and textures from your subjects that you could apply to other designs (see Edges, page 148).
- Develop your stick people (page 98).

MAPS & DIRECTIONS

Most people will happily draw a map to give directions; verbally complex directions can be easily simplified into a basic visual form. Some maps are more complex than others; working out what information needs to be included is as much a part of the skill of drawing the map as the physical draftsmanship. A hastily sketched road map will look very different to the creative cartography that might go into a map of picturesque walks around a village, but both fulfill their purpose. For this exercise, draw your route from home to work. Imagine the route from above; sketching out the roads you take to scale and noting landmarks on the way. To embellish a map you could include enlarged landmarks, sketched using approaches from page 50 and drawn as if you were looking at them head-on.

EXERCISE: **MAPPING A ROUTE**

Applications
- A road map to direct a friend or colleague.
- A map of the floor plan of a building.
- A decorative map.

MAPS & DIRECTIONS

METHOD

Illustrate your route to work. Roughly sketch out a map of the route from above in pencil and note down any major landmarks along the way.

Clarify the route by drawing over the pencil in pen and lightly erasing the earlier marks when the ink is dry.

Draw in the major landmarks
from observation, photographs,
or memory. Add color and tone
if needed.

ALSO TRY...
Laying out a room. If you're
thinking about different
arrangements of furniture
in a room, try mapping
them on paper and trialing
alternatives.

TO IMPROVE...
• Practice sketching key
 features in the landscape
 (pages 50–57).
• Practice drawing interiors
 to gain a better sense of
 space in drawings (pages
 32–35).
• Practice making clear,
 bold lines (page 18).

THE ULTIMATE STICKMAN

The stickman is a simplified human figure. At its worst the stickman can come to symbolize the insecurities many people have with their drawings; people often defensively state, "All I can draw is stickmen." Just like all other aspects of your drawing, your stickmen can always be improved. If you have a shorthand for the figure you can use it for anything from storyboarding and instructional drawing to planning compositions for paintings and sketching figurative scenes. Your basic figure might lean towards the cartoonlike, or it might be more representational; it is up to you. The stick people in this exercise demonstrate an evolving anatomy that becomes more complex as they need to communicate more complex ideas. The first represents the presence of a person and nothing more. The final stickman is fully articulated and could adopt a plethora of poses. When using them in context, pick the level of detail that is suitable for what you want to communicate.

EXERCISE: **EVOLVING STICKMEN**

Applications

- **Comparison:** For drawing a figure in relation to any designed objects, from chairs to buildings.
- **Storytelling:** Stickmen can be used in storyboards or instructional drawing.
- **Cartoons and imaginary figures:** The basic figure can underpin characters in comic strips, simple character design, and in pictures drawn for fun.
- **All of these stickmen are useful for something;** even the most basic one can signify complex attitudes and ideas.

THE ULTIMATE STICKMAN

METHOD

Draw each of the following six stickmen, then try drawing them performing actions to understand the limitations of the figure. The first, most basic stickman has crude, purely symbolic features: a head, body, arms, and legs.

The second figure has better proportions; the legs start halfway through the body.

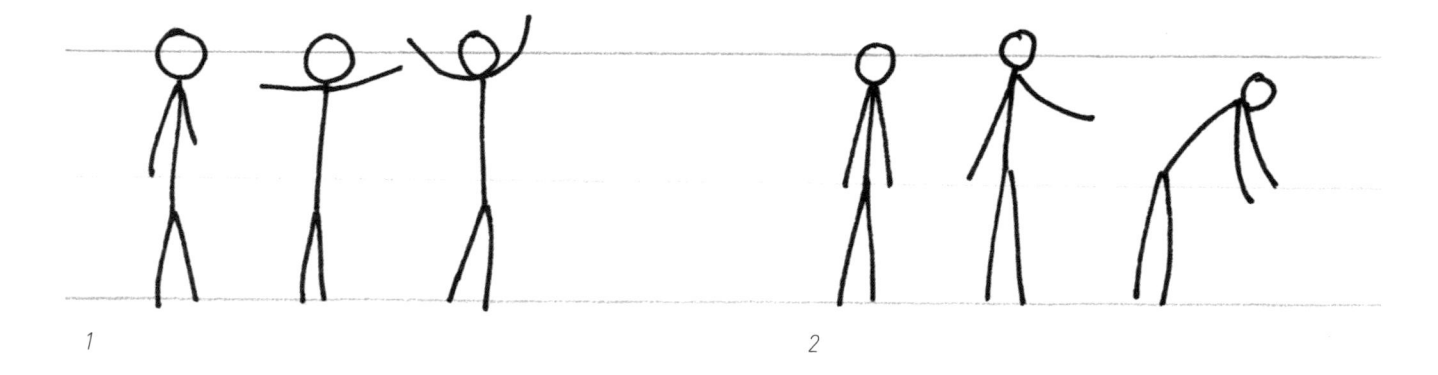

1

2

Stickman number three has shoulders and hips and looks a little more human.

Stickman four has joints, creating upper and lower arms and legs, hands, and feet.

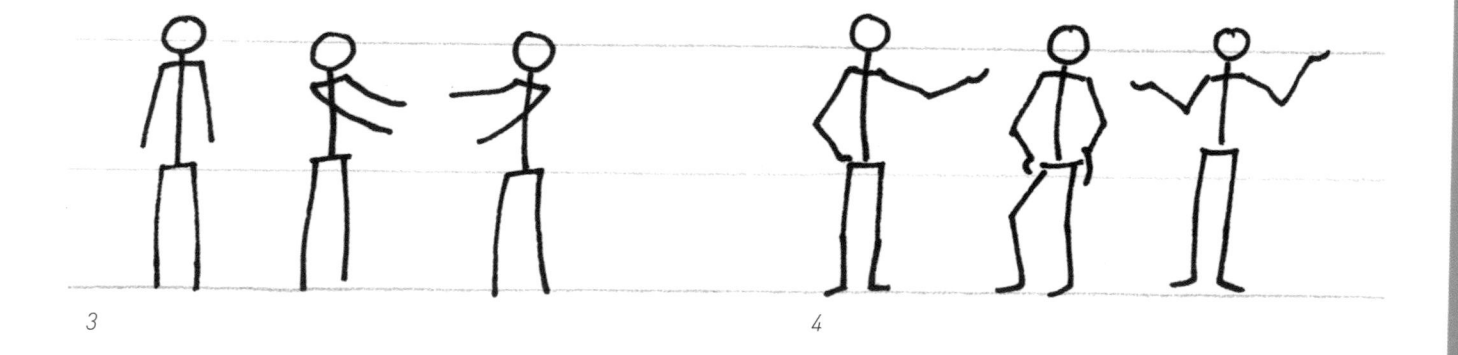

3

4

Stickman five has a spine and a torso with mass blocked in with simple tone.

Stickman six has tapering limbs, creating a body with volume.

5

6

ALSO TRY...
Drawing a greater variety of stickmen. Draw simple cartoon figures, giving them different body shapes and clothing.

TO IMPROVE...
- Draw more figures from life (pages 46, 62, and 102–123).
- Practice drawing your stickmen in a variety of poses.
- Learn more about the anatomy of the human body (pages 120 and 172).

IN A LIFE CLASS

Life drawing is the practice of making an observational drawing directly from a model, typically unclothed. Although many artists employ life models for one-to-one sittings, most life drawing takes place in group sessions with several people drawing from a model. Life drawing isn't just about making pictures of unclothed figures; it is a great way to exercise core drawing skills. Fundamentally it is an exercise in observation training you to look properly at your subject, using selective drawn marks to make efficient sketches within the time constraints of poses. At its best a life drawing class can be the heart of an artistic community, encouraging skill sharing and providing an environment in which to meet others who are keen on drawing.

ABILITY & EXPERIENCE

Life drawing classes are often pitched at different levels of experience with tutored classes for beginners, or improvers and untutored drop-ins open to all abilities. Pick the class that you feel best reflects your confidence level, but be brave—you shouldn't be put off attending by inexperience. Do some research to find out whether you need to bring your own materials, and if you do, use the advice in this chapter to guide your choice of equipment.

MODEL & POSE TIMINGS

Remember that the model sitting for the class is a person, not just a subject for the drawing. Respect the life model and be considerate in your language towards them; they are providing the source of inspiration for your work! If you're used to drawing from photographs, still life, or landscapes, then getting used to the speed of shorter poses will be your first challenge. The time constraints of a life class will require a compromise; make a conscious decision about how you will direct your time in a drawing and don't try to draw everything all at once. The exercises in this chapter will help you to get started.

If you haven't been asked to take specific materials to a class, here is some suggested equipment. Don't overwhelm yourself with too many options at your first class, but go prepared. The board and paper could be any size you prefer; if the life class has easels you can work really big!

A VARIED KIT
- Ink and dip pen
- Watercolor brushes
- Charcoal sticks
- Charcoal Pencils
- Graphite Pencils
- Eraser
- Knife
- Pencils
- Sharpener
- Drawing Board
- Paper
- Folder

A SIMPLE KIT
- Sketchbook
- Pencils
- Eraser
- Sharpener
- Ballpoint pens

SETUP
For the drawings in this chapter, you'll usually be set up at an easel or with a drawing board on your lap. Think about your position in the room, as it will affect the poses you see, and make sure your paper is well lit.

WARM-UPS

It is worth spending a little time warming up before committing yourself to a longer drawing. I always think of these first sketches as sacrificial drawings intended to establish a connection between your eye and hand and get you making marks. You can use this exercise to help you draw quick poses, or use it at the begiinning of a longer pose before starting a more earnest drawing. If you've never drawn before, this can be a good exercise to start with. Because the exercise involves not looking at the paper you have an excuse to make strange and misproportioned drawings!

EXERCISE: **BLIND CONTOUR DRAWINGS**

What you need:
- Ballpoint pen or pencil
- Sketchbook

Ideal pose length:
1–3 minutes per pose

AIMS & ATTITUDES
This is a commonly used exercise to help you make clear observations, unrestricted by the worry of how the drawing looks. It will also help you to identify edges, make decisions about where to draw a line, and it will encourage confident linear mark-making.

WARM-UPS

METHOD

Secure your paper and sit looking at the model; don't look at the paper at all throughout this drawing. Touch your pen or pencil to the paper, near the top, and focus your eyes on the top of your model's head. Slowly let your eye trace a line around your subject. As your eye "draws" its way around the subject, let your pencil follow the same movements on the paper.

Draw a continuous line around your subject's outline, moving inward when necessary to follow lines in the body. If you lose your place, you can look down at your drawing briefly, reposition your pencil, and continue the process, keeping your eye on the subject as you draw.

When the time is up, lift your pencil off the paper and take a look at what you've drawn. Expect the drawing to be bizarre and inaccurate; after all, you weren't looking at it! Repeat this exercise regularly to help you get used to looking and drawing.

ALSO TRY...
Making blind contour drawings of people outside of the life drawing class, drawing without looking back at the paper to improve your observational skills.

TO IMPROVE...
- Learn more about drawing edges (page 148).
- Explore different ways of making lines (page 18).
- Read more about observation (page 144).

GESTURAL DRAWING

A gestural drawing captures the energy and feel of a pose. In poses lasting just a few minutes a model will be able to hold a more dynamic posture and this energy can be captured in a swift, gestural study. Although the drawing is still rooted in observation, you'll be drawing how the pose feels as much as how it looks. The time constraints of a quick pose means you have to sacrifice some accuracy to maintain the right feeling in the drawing, and a good way to do this is to set yourself some boundaries to stop yourself getting caught up in detail as you draw. For this exercise, you'll only have three lines with which to capture your subject.

EXERCISE: **3 LINE DRAWING**

What you need:
- Charcoal pencil
- Lots of paper

Ideal pose length:
10 seconds–5 minutes per pose.

AIMS & ATTITUDES
Gestural drawings should be made with energy, but they shouldn't be made in a panic. Look first, then draw. Some drawings will work better than others and you may find you can make several sketches during one pose. This is an exercise in selection; you must learn to make quick, instinctive decisions about where to draw a line, and to put those lines down confidently.

GESTURAL DRAWING

METHOD

Take a moment to look. Draw the first line, from the top of the pose to the floor, capturing energy in the pose, using a flowing and intuitive mark. You'll have no time for detail. Don't let the line hesitate. If you don't like where it has gone, start again next to the first line.

The next line should balance the first line. Keep it confident, keep looking at the model. There will be lots of things you aren't able to capture; that is fine. This exercise is all about being selective.

The final line can create a focus and interest in the drawing. If you have time, try the same pose again, and try to improve on the drawing. Some drawings will come out well, some will not.

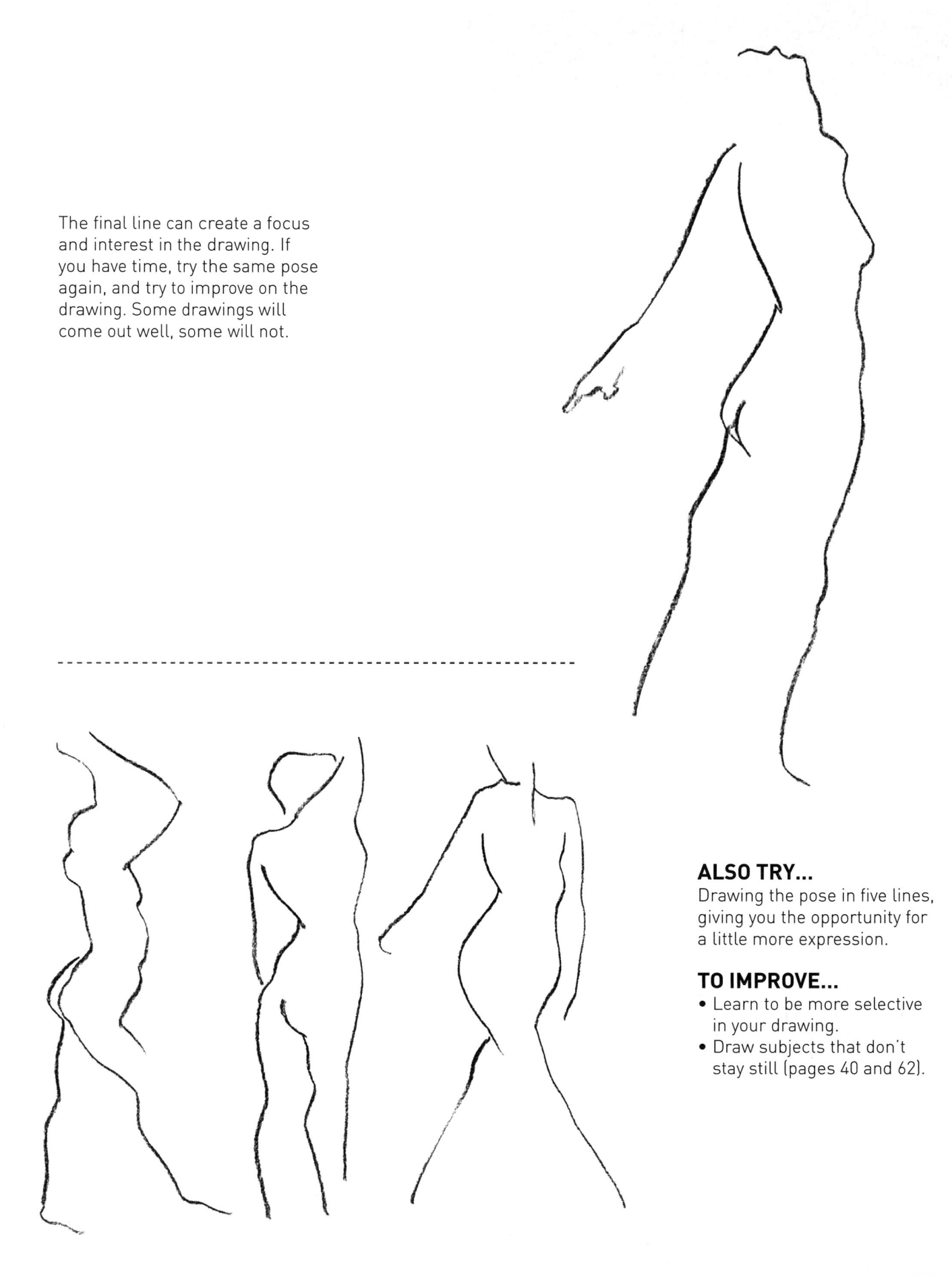

ALSO TRY...
Drawing the pose in five lines, giving you the opportunity for a little more expression.

TO IMPROVE...
- Learn to be more selective in your drawing.
- Draw subjects that don't stay still (pages 40 and 62).

NEGATIVE SPACE

Our observations of the figure are inevitably affected by how we expect a body to look. We bring fewer preconceptions to the abstract shapes of spaces that surround the figure, and we can use those spaces to help us see the figure more objectively; by drawing these negative spaces around a figure you can arrive at the silhouette of the body.

EXERCISE: **DRAWING IN NEGATIVE**

What you need:
- Pencil
- Sharpener
- Eraser
- Paper

Ideal pose length:
3–10 minutes per pose.

AIMS & ATTITUDES
This exercise trains you to see negative spaces; do your best not to become distracted by the details of the body. Bear in mind that when you draw a line around the boundary of the figure you are simultaneously drawing the boundary of the negative space.

NEGATIVE SPACE

METHOD

Start with a clear, simple shape, ideally a small shape enclosed by the body. Draw the space as accurately as your time allows.

Draw the next nearest shape, judging the relationship between the spaces. Don't draw the body in between, but maintain an awareness that the spaces are creating the silhouette of a figure.

Draw the negative space around the figure. You might also want to draw in the shapes of the furniture that the model is posed on in a similar way. If you want to, you can darken the negative spaces to make the figure stand out.

ALSO TRY...
Using a viewfinder to create an artificial boundary around the body. A viewfinder can easily be cut out of card, or backing of your sketchpad.

TO IMPROVE...
- Practice drawing chairs and stools in negative.
- Learn to recognize abstract shapes more easily (page 152).
- Learn to judge the relationships between shapes (page 150).
- Learn to identify the boundary around a figure more easily (page 148).

Using a viewfinder can help you to identify the negative spaces around the body.

TONAL DRAWING

We see the world around us by perceiving tone and color. Tone, also called value, refers to how dark or light we perceive something to be. When you are drawing the figure, you are presented with a complex map of tones that you need to selectively translate into drawn marks. Judging how light or dark a relative tone is will take practice. It can be helpful to separate tones into broad categories, looking for the lightest lights, mid-tones and darkest darks. This exercise involves adding a mid-tone to the paper first, erasing away to represent light, and adding darker marks to achieve shadows.

EXERCISE: **SUBTRACTIVE TONE**

What you need:
- Charcoals sticks
- Soft cloth
- Plastic eraser
- White paper

Ideal pose length:
5–20 minutes per pose.

AIMS & ATTITUDES
This exercise will help you simplify the figure into blocks of tone. You needn't draw all the shadows you see; be selective and make decisions about what to put into your drawing and what to leave out. Learn to see shadows as a jigsaw of blocks of light or dark and develop a vocabulary of tonal marks for describing these shapes.

TONAL DRAWING

METHOD

Prepare your paper by lightly scrubbing a stick of charcoal over the paper and then rubbing it over the surface with a cloth. Aim to cover the surface with an even mid-tone of gray.

Take a good plastic eraser, cut to a point, and start drawing in shapes of light. Start from a big, clear shape of highlight and erase areas of light as you see them, maintaining an awareness of the relationships between shapes. Keep the drawing simple and draw the shapes of highlights, leaving the mid-tone shadows behind.

Once you have drawn in simple blocks of light, use your charcoal stick to draw in darker shadow shapes, drawing in the sharp edges of shadows to add clarity to your drawing.

ALSO TRY...
Drawing on a mid-tone paper. Choose a paper that isn't too dark and draw the shapes of shadows on in charcoal, allowing the paper to stand in for the mid-tones. Use white chalk or gouache to create the shapes of highlights.

TO IMPROVE...
• Learn to recognize tones more easily (page 154).
• Explore different ways of drawing tonal shapes (page 36).

DRAWN ANATOMY

When a model adopts a pose, we see the underlying structure of bones, muscles, and fat expressed on the surface of the skin. Figure drawings can have a similar underlying structure of simple lines and shapes, a drawn anatomy that relates to the physical anatomy of the human body. By understanding the structure of the body better, you can learn to make more focused and selective life drawings. This tutorial demonstrates how you might use observations of anatomy to develop a simple drawn anatomy, taking the neck and shoulders as an example.

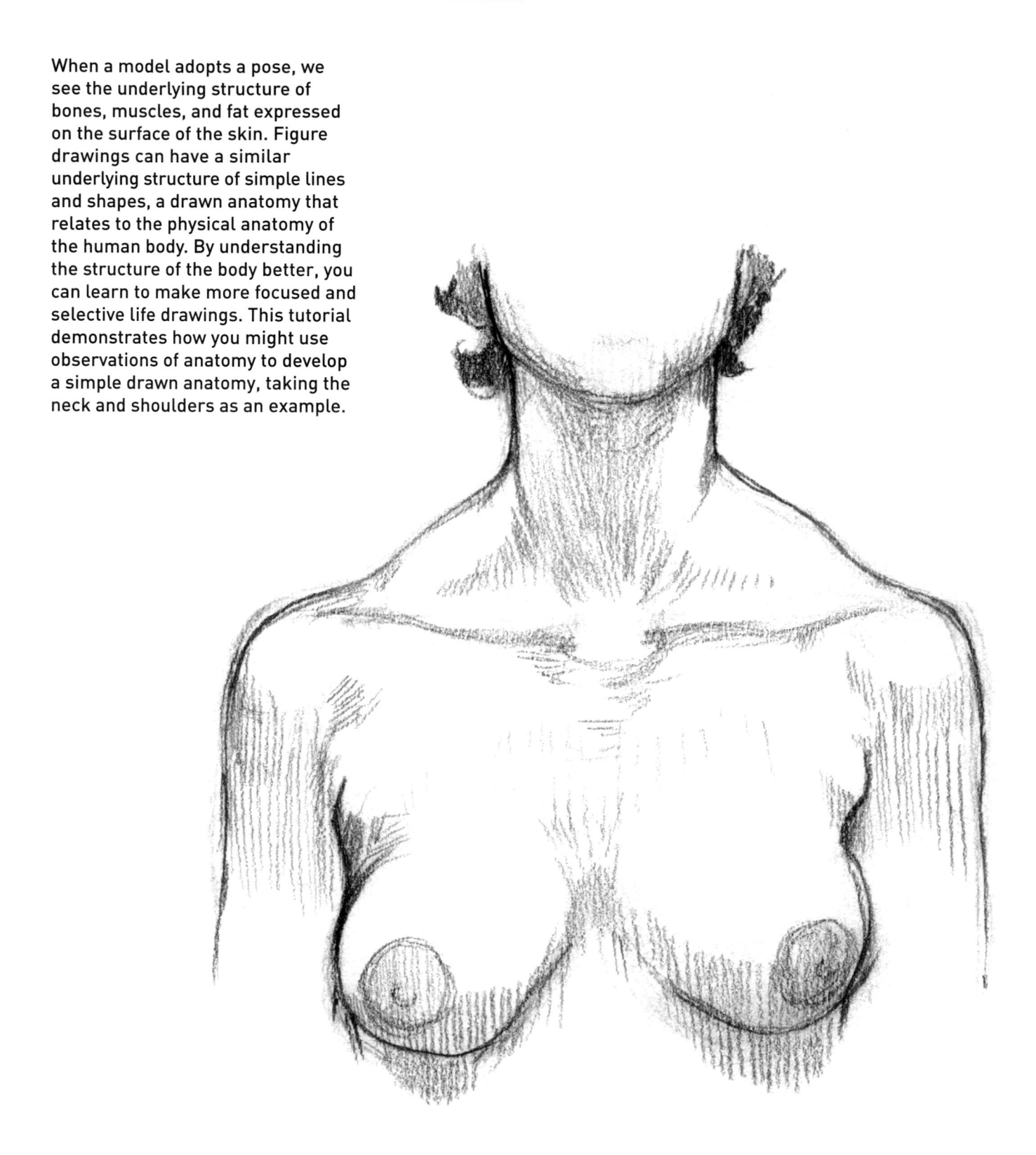

EXERCISE: **A CONSTRUCTED DRAWING**

What you need:
- Pencils (HB, 3B)
- Eraser
- Sharpener

Ideal pose length:
10–30 minutes per pose.

AIMS & ATTITUDES
By developing a basic knowledge of what is underneath the surface of the skin you can learn to make clearer observations of the figure. By developing simple structures to sketch down underneath your figures, you'll create a scaffold of marks on which to hang your observations of the body. If you like the approach, develop your knowledge of the figure by studying anatomy alongside making focused observational studies. Everybody draws differently, so this approach won't suit everybody.

DRAWN ANATOMY

METHOD

Research the anatomical structure of the part of the body you wish to study, making sketches from anatomical text books and develop a working understanding of that part of the figure, paying attention to muscles and bone structures you see demonstrated on the surface of the skin.

From your observations of the figure and from your research, develop some simple shapes that underpin what you see in that part of the body. Instructional drawing books that focus on the figure might also suggest a framework of constructive shapes.

When you observe your area of study in a life drawing class, make quick sketches, laying down the underlying shapes you have developed, and elaborating on those structures based on what you are observing.

ALSO TRY...

Move on to studying other parts of the body and develop a complete figure construction. Use this to practice drawing simple figure poses from your imagination.

TO IMPROVE...

- Improve your judgment of relationships between major landmarks on the figure (page 150).
- Study human anatomy (page 172).
- Learn more about other suggested structures from figure drawing books (page 172).

AT THE DRAWING BOARD

This chapter is an extension of the section on drawing at home, intended for days when you can carve out a little more time to draw. If you are lucky enough to have a dedicated studio space then perhaps this is drawing to be done there. If not, do it at the kitchen table, in your bedroom, or anywhere you can focus fully on your work. Here is some advice to help you get the most from your time.

PRACTICAL ADVICE

- **First you'll want to cut out all distractions.** Remove anything from your immediate vicinity that will pull you away from drawing.

- **Put technology aside.** Even if you're drawing from a screen, steer clear of the internet for a few hours, and set your phone to silent.

- **Don't let other people distract you.** Perhaps your first drawing could be an attractive "Do Not Disturb" sign for your door.

- **Set a minimum time.** Allow yourself enough time to relax into drawing and don't forget to make a few warm-up sketches before you start in earnest.

- **Don't play the starving artist.** Have something to eat! Have a snack and a glass of water to hand so that nothing will pull you away from the task ahead.

- **Don't feel under pressure.** This is time to learn, play, and experiment. It is as much about the process as the outcome.

- **If you like music, put on some music.**

WARM-UPS

Before starting any serious drawing, set aside a few minutes for making some sacrificial warm-up sketches. This will help you coordinate your eye and hand and loosen up your wrist a little. The paper-to-paper exercise in this section is a good warm up, but you might also want to start with any exercises from Chapter 2, a drawing of the room from page 32, the alternative exercise on page 83, or the blind contour drawings from page 104 applied to objects rather than a model.

IDEAL KIT

Get your drawing kit out, but don't overwhelm yourself with too much variety. Picking your materials is as much a part of the drawing process as is putting pencil to paper. This is your time to try new tools, or to become more competent with the materials you enjoy; explore the range of potential that drawing has to offer. Nobody is looking over your shoulder or judging your work; you have permission to make mistakes, to take risks, and to fail. Organize your drawing space, make sure you have a good surface to rest your paper on, and ensure the kit you intend to use is accessible.

PAPER TO PAPER

It is often useful to develop a few basic drawing exercises that help you relax into the process of looking and making marks. Ideally these exercises should require minimal equipment and a readily accessible subject—and what could be more accessible at your drawing board than a ball of paper!

This is a great exercise in tonal drawing and shape recognition, and it can be a wonderfully meditative way to get lost in drawing something relatively simple. It is cheap and easy to set up, and was first suggested to me by the artist Daphne Sandham. Daphne advocates eating a square of chocolate at the same time to help you maintain concentration, and drawing for the length of a song; so put on a 3–5 minute song and draw until it finishes.

EXERCISE: **TONAL PLANES**

What you need:
• Pencil
• Eraser
• Sharpener
• Paper
• A desk lamp

Time:
The length of a song.

Setup:
Crumple up a ball of paper and sit it on the table in front of you with a desk lamp providing directional light.

AIMS & ATTITUDES
This is a commonly used exercise to help you make clear observations, unrestricted by the worry of how the drawing looks. It will also help you to identify edges, make decisions about where to draw a line, and it will encourage confident linear mark-making.

PAPER TO PAPER

METHOD
Start your drawing with a shape in the middle of the ball of paper; don't begin with the outline of the ball. Draw the abstract planes that you see, drawing one shape next to another.

Start rendering tone using quick, simple diagonal marks. Judge how light or dark each shape should be relative to the shapes around to it. Save your darkest mark-making for the shadows in the creases of the paper.

Work out toward the edge of the paper, but don't feel that you need to draw the whole ball; stop when the song ends.

ALSO TRY...
Taking the same approach with other objects that are made up of many small shapes next to one another, a bunch of flowers for example.

TO IMPROVE...
- Learn to group tones into darks, mid-tones, and lights (page 154).
- Learn to see abstract shapes more clearly (page 152).
- Become better at judging relationships between points (page 150).

DRAWING HANDS

We use our hands for reaching out and interacting with the world; they are also expressive tools for communication. Leaving your model's hands out of a drawing is to neglect an important part of their identity, but if you're drawing a full figure you might only have a few moments to capture the gesture of the hand. Spending some time making focused studies of your own hands will allow you to concentrate on the varied shapes they can create.

Simplifying hands into manageable structures will help you break down what you see, creating a framework on which you can hang your observations. This exercise uses a red pen for the underdrawing, and a black pen for later lines. Alternatively, you could do the underdrawing in willow charcoal, rub it back with your hand, and over-draw in compressed charcoal pencil, or make the drawing in pencil, erasing between stages.

EXERCISE: **HAND STUDIES**

What you need:
- Red ballpoint pen
- Black ballpoint pen
- Paper

Time:
10 minutes per study.

Setup:
Secure your paper and pose one hand on the table so that you can draw it with your other hand. You might want to prop a mirror up in front of you so that you can draw your hand at a range of different angles.

AIMS & ATTITUDES
The red pen in this exercise helps you separate out the processes of establishing and constructing the hand from elaborating on the form, allowing you to lay down confident black lines to clarify your drawing once you have worked through the proportional problems. Use the exercise to help you think about drawing in layers, dealing with one problem at a time, giving consideration to the kinds of marks you use at each stage.

DRAWING HANDS

METHOD

Place your hand in a pose and spend 10 seconds really looking at it before you begin drawing. Using your red pen, start by establishing the position of the wrist, the mass of the back of the hand and the "mitten" of the fingers. The distance between the wrist and the knuckle is about the same as between the knuckle and the fingertip.

Draw the shape of the thumb, and divide the establishing mitten shape into fingers, as if you were a sculptor carving more detail into the drawing. Look for lines of shadow or triangles of negative space between digits.

Use the black ballpoint pen to elaborate on the outline of the hand and fingers. Use the structure of the underdrawing to guide you, and draw the lines and shapes of the shadows you see, keeping your marks simple, selective, and flowing, and experiment with the weight of mark as you draw.

ALSO TRY...
Making studies of other people's hands in action, holding cups in cafés, typing on keyboards, or drawing in art classes. Try to capture the shapes quickly as they move, filling a page with swift, incomplete sketches.

TO IMPROVE...
- Learn to see edges and shapes more clearly (pages 148 and 152).
- Develop your observation of negative spaces (page 112).

FOLDS & FABRICS

Drawing fabric can be a great opportunity for exploring mark-making, using different marks for tonal shapes, surface pattern, and contour lines. Making drapery studies will help you draw clothed figures as you become better at simplifying the complex shapes of fabric into efficient marks. You'll have trouble re-posing the fabric in exactly the same position, so you'll need to complete a study in one sitting, or to be able to leave it in the same place until you are ready to continue the drawing. Start off using a plain cloth for your first study, then move on to something patterned; I have used a tea towel as the subject for this drawing.

EXERCISE: **DRAWING DRAPERY**

What you need:
- Pencil
- Dip pen
- Ink
- Fabric
- Paper

Time:
30 minutes.

Setup:
Pin your fabric up so that it hangs from a point and broadens into a triangle, draping over a table or a chair. Make sure you have a clear, directional light source that will remain constant as you are making your drawing.

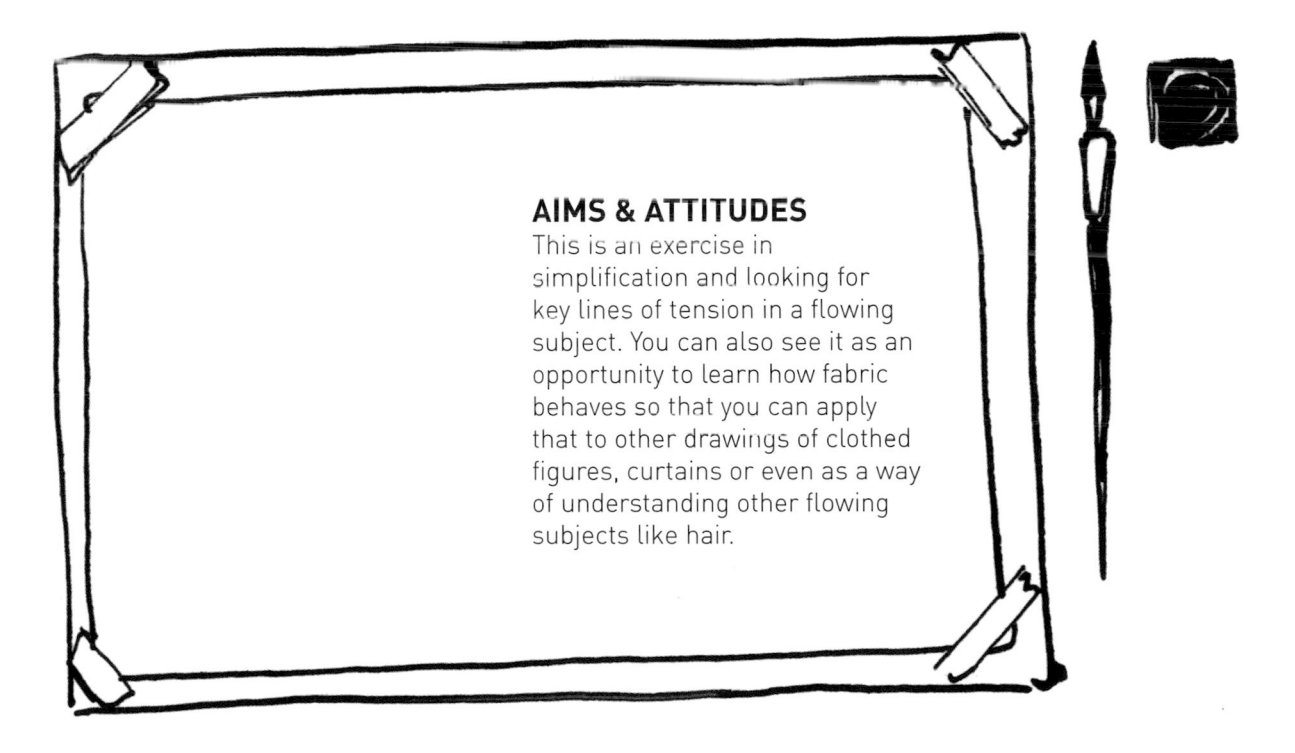

AIMS & ATTITUDES
This is an exercise in simplification and looking for key lines of tension in a flowing subject. You can also see it as an opportunity to learn how fabric behaves so that you can apply that to other drawings of clothed figures, curtains or even as a way of understanding other flowing subjects like hair.

FOLDS & FABRICS

METHOD
Establish the shape of the
fabric with a pencil, looking
for its overall outline and paying
attention to the negative space
around it (page 112).

In pencil, draw the edges of major
folds running through the fabric,
using a varied speed and weight
of line to convey tension. Ignore
smaller folds and patterns.

EXERCISE:

A PHOTOGRAPHIC PORTRAIT

What you need:
- A good portrait photograph
- Pencils
- Paper
- Sharpener
- Eraser

Time:
45 minutes.

Setup:
Set yourself up so that you can clearly see your paper and the image you are working from. Work on an angled surface, rather than flat on a table.

AIMS & ATTITUDES
The aim of this exercise is to bring the attitudes of drawing from life to a photograph, making selective decisions as you draw. It also provides an alternative technique to the earlier portrait studies suggested on page 28.

FROM SCREEN TO PAPER

METHOD

This approach involves drawing from the features outward. Start by establishing some simple proportions. Jot in the position of the eyebrow, eye, bottom of the nose, center of the mouth, and bottom of the chin.

As you draw, imagine the person in the photograph is in front of you. Draw as if what you are seeing is three-dimensional, and draw the shapes of the shadows that you see defining the features; don't try to draw the features as you imagine they should look. Leave out less significant shapes.

As you reach the chin, draw up from the jawline and around the ear to the shape of the hair and forehead. Simplify and stylize the line as you draw, emphasizing characterful shapes in the face. Decide how you will use the background to serve the drawing best; you don't have to copy everything you see in the photograph.

ALSO TRY...
Collaging photos together and inventing your own compositions to draw from.

TO IMPROVE...
- Practice drawing faces from life (pages 28 and 46).
- Practice drawing edges and lines selectively (page 148).
- Think about how your memory and imagination affect your drawings (page 144).

DRAWING SKILLS
ABOUT DRAWING

A VISUAL LANGUAGE

Drawing is a visual language, a means of describing the observed or imagined world in a vocabulary of meaningful marks. Just as some occupations carry with them their own verbal language—the medical language used by doctors, lawyers using legal terminology, etc.—so different kinds of drawing require different visual vocabularies. When you are deciding what kind of marks to use in a drawing, think about the elements of the subject you'd like to describe to the viewer. Do you want to draw attention to the way light falls across a landscape? Perhaps a tonal vocabulary of marks would be best. Do you want to record the complex pattern on a piece of fabric? A more linear vocabulary might suit this drawing.

We use drawing to communicate ideas and observations. The communicative intention of some drawings is clear: an architect's drawings of a house might help a client envisage their future home, or inform the builder in how to construct it. The intention of a portrait might be to record the likeness of the sitter for posterity and for artistic satisfaction. Some drawings will be made for you alone, as a record of a moment or an aid to memory and some might be made in order to practice the process of looking and mark-making. Whatever the purpose of the drawing, think about what you are trying to say in it, think about the later viewer, and select a vocabulary of marks that will best communicate your intentions.

WHAT MAKES A GOOD DRAWING?

Judging the success of a drawing can be very subjective. You could judge a drawing by how effectively it fulfills its purpose, even if you are not aware of the purpose of the drawing as you make it. Don't make drawings for no reason. By all means draw to practice, or sketch spontaneous responses to what you see around you, and always be prepared to take risks—but, whatever you do, make each drawing purposeful.

When you are judging whether a drawing has been successful or not, think about its purpose and the boundaries that limited it's creation. You can find something valuable in every drawing; where a drawing has elements that haven't worked you can learn from those weaker parts, and when parts of the drawing have worked well, these can be built upon in future work. Boundaries and constraints are important for creating drawings with focus; time limits, limited materials, and difficult subjects all introduce challenges that will both train you to be a better draftsman and to create purposeful sketches. A drawing always contains compromises: proportional accuracy might be partially sacrificed in favor of gestural energy; tonal rendering might be simplified into a few linear marks in order to save time. Here are two examples of drawings made with different intentions.

This drawing of fabric was made to capture the flow of the materials and also to practice a new approach to mark-making with dip pen on smooth, heavy cartridge paper. Its success as an experiment contributes to its overall success as a drawing.

This drawing was created as a spontaneous sketch, recording the impression of a tree. The drawing was made to capture the shape and flow of the tree and, it was made quickly on location with graphite stick on cartridge paper. Tight proportion has been sacrificed for gestural energy.

ATTITUDES & TECHNIQUES

Attitudes are ways of thinking about and approaching drawing; the attitude you take to drawing practice is as important as the techniques you use to make individual pictures. Techniques, such as the ones in this book, give you a starting point and a process to work through when translating your observation of the world onto paper. Take all techniques with a pinch of salt; there is no right or wrong way to draw, just better and worse ways of achieving a certain outcome, or developing a particular way of seeing.

Some techniques help you structure your time, the way you think about your subject, and the way you make your drawing; others provide clever tricks to make your drawing more striking. Use and adapt all drawing techniques you learn about; combine them with other things you've read or been shown by fellow artists, discard any approaches that don't suit you and bring in your own understandings of the visual world. Given time you can be sure of developing an approach to drawing that is robust, authentic, and unique.

SOURCES OF IMAGERY

This book focuses on drawing from observation. When we make observational drawings, we are gathering visual information; we select important elements of what we see and simplify those elements into marks. When we look from our subject back to the drawing we briefly hold a memory of the subject in our heads before we jot it down, so observational drawing partially relies on memory. Everything we observe and briefly memorize contributes towards the schemas that make up our understanding of the world, creating stock images of objects in our heads that in turn inform our imaginative drawings.

For example, every chair we have ever seen contributes towards our idea of what a chair looks like, and this is what we are imagining when we draw a chair from our heads. Our knowledge of the visual world and our imaginative capacity feed back into our observational drawing, helping select interesting and relevant elements of our subject to draw. Making any drawing will always involve utilizing observation, memory, and imagination at once.

Observation

Memory

Imagination

Observation

Improving your observation means spending more time looking at your subject and less time looking at your paper, strengthening the connection between your eye and hand, and learning to be selective about what you draw. Reduce the distance your eye has to travel between your subject and drawing to make it easy to make direct comparisons.

Easel and subject: Position your subject to minimize the distance your eye has to travel.

Memory

You can only remember what you have first observed. If you make a drawing from memory you'll see the gaps where you didn't observe your subject properly. Try looking at an object for a few minutes, then draw it from memory. You often hold a particular line, point, or shape in your head as you transfer it onto paper. Improve that process: look at your subject, select a line, point, or shape, hold it in your mind, then look at your paper and draw it, then go back and find the next line.

Look, hold, draw

Imagination

When you first take up drawing, your imagination can hamper you; you think you know what the world looks like, so you don't observe it properly and draw what you think is there. First, learn to draw objectively, then, as you develop a better knowledge of your subject by looking, use your knowledge and imagination to help you make better selections in your drawings.

CORE SKILLS

Drawing is a composite skill made up of skills of perception, tempered by elements of imaginative design, and bought into being through tactile mark-making. The perceptual skills identified below are inextricably linked and are all required when making any drawing. Some types of drawing are weighted towards particular skills and they can be practiced in order to improve those skills.

ASK BETTER QUESTIONS

Sometimes drawing can be a flowing, intuitive process, but often it will involve a lot of mistake-making and problem solving. Making better drawings is about identifying problems in order to solve them in your drawings. Especially when you're just starting out, your progress can sometimes be hampered by a niggling internal monologue, saying things like:

- "I can't draw faces."
- "That arm can't possibly look like that."
- "This drawing isn't going very well."

This is your internal critic speaking, and it can be more restricting to your progress than any lack of ability. In order to develop, you need time to learn to draw without negative internal criticism, so instead nurture an internal tutor. Turn your self-criticisms into constructive questions that you can then try to answer in your drawings:

- "Where should I start this drawing of a face?"
- "Is that arm foreshortened? How can I make sense of it's shape?"
- "What are the problems in this drawing that make it look unlike the subject? How can I improve on it?"

Allow yourself time to step back from your drawing to ask these questions, and when you are drawing allow yourself to become absorbed in the process of looking and mark-making without criticism. It takes time to learn how to critique your own drawings constructively but it'll come with practice.

A TOOLBOX OF SKILLS

As you make a drawing you'll encounter perceptual problems and drawing problems that you'll need to solve. Different problems might require different ways of seeing and mark-making. Over time you develop a toolbox of perceptual skills, and types of mark-making that will help you solve certain problems. Get used to dipping into that toolbox to find the right way of seeing to solve the problem. Drawing techniques are just tools that help you solve specific problems in a particular way. To become a versatile draftsman, you'll need to develop as comprehensive a toolbox of skills as possible.

EDGES

Most drawings start with a line. Lines represent the journey your eye takes around a subject, often moving around the boundary between an object and its surrounding environment, or around a shape or shadow. Looking for edges that you might represent with lines is a fundamental skill of perception.

EDGES OF OBJECTS

The edge around an object is like a horizon line, your subject's form continues, but out of your sight. The outline you draw represents this horizon; we are able to see the boundary as the result of contrasts between an area of light and an area of dark.

EDGES INSIDE OBJECTS

When your eye moves inside the shape of your subject's outline you'll start seeing further shapes, continuing the edges of the subject within the boundary of its outline.

TONAL EDGES

When simplifying tone, you might want to draw the outlines to the shapes of shadows you see on your subject. This will mean making decisions about where a line could go along a gradient of light and dark.

PRACTICAL BIT: OUTLINE, INTERIOR

Make some linear drawings following the process of looking for the edges of an outline, then shapes inside the outline, then the edges of shadows.

RELATIONSHIPS

Judging relationships between elements of your subject and getting to grips with spatial relationships between objects on a page is key to achieving harmonious compositions and accurate proportions. It is often helpful to start by judging big relationships, honing your observation down to point-to-point relationships later. Learn to judge relationships by eye and only bring in measuring tools when you need them.

RELATIONSHIPS BETWEEN LANDMARKS

The relationships between objects on a page make up the broad composition. Those objects will be made up of basic shapes that sit in relationships to one another.

RELATIONSHIPS BETWEEN POINTS

A line describes the relationship between two points that sit like co-ordinates on a map; to draw an accurate line you want an idea of where the points sit along it. Look for points in your drawing that you can relate to other points: junctions between lines or starting and stopping points of lines.

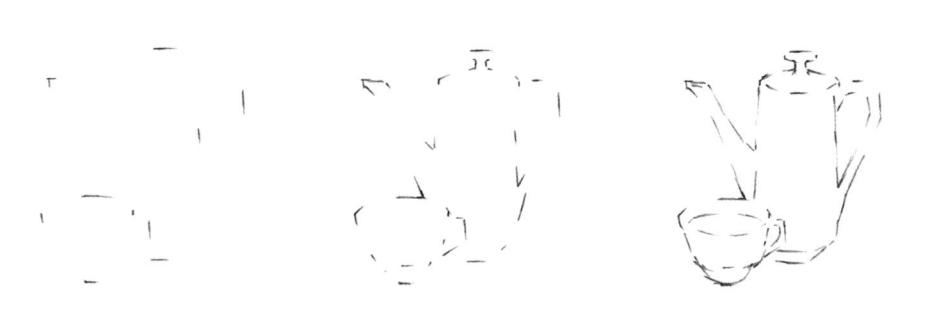

PRACTICAL BIT: **MEASURING**

When you can't judge a relationship by eye, use drawing tools to help you. You can use your pencil like a ruler to check angles between points or measure comparative distances. Close one eye to flatten what you see and hold your pencil out at arms length for a consistent measurement. You'll look super arty doing this. If you are looking for accuracy in your drawing, here are some useful questions to ask yourself as you check your drawing:

What is horizontally in line with this part of my subject? Is that the same in my drawing? (If it isn't, change your drawing so that it is. Do the same for vertical relationships.)

Horizontals, verticals

Diagonals

Is the angle of that line in my drawing the same as I see in my subject? (Line up the diagonal with your pencil and, keeping your arm straight, transfer it across to your drawing. If the angle isn't the same, change it in your drawing.)

How much of one part of the drawing would fit into another part? (You don't need to make your drawing the same scale as you see the subject, but you can still make comparisons between one length and another in your subject and your drawing to check relative proportions.)

Measuring

SHAPES

When you are drawing, it helps to look for large shapes to begin plotting out your drawing in a very general way, and then to work into the drawing finding increasingly smaller shapes that fit together like a jigsaw puzzle making up your impression of your subject.

SIMPLIFIED SHAPES

At first look for big shapes, looking for general relationships in the composition. Practice simplifying complex objects into basic forms.

NEGATIVE SPACES

Don't just look at the shapes your subject makes, but also look at the shapes surrounding it. Sometimes it is easier to draw your subject in negative, looking for shapes around it first, or as a problem-solving exercise.

TONAL SHAPES

Look at your subject like a jigsaw puzzle of shadow shapes, fitting together to create the whole picture.

PRACTICAL BIT: **SCULPTURAL APPROACH**

Think like a sculptor; you are starting with a block of granite
(the blank page) and chipping away big shapes, then smaller
shapes to finally arrive at the areas of details.

TONE

We see the world as graduations of light and dark. At first, the complexity of tone can be overwhelming. The more tonal drawings you make, the more clearly you will learn to judge differences in tonal values. Beginners often make contrasts too extreme; most of the world is a mid-tone, with the lightest lights and darkest darks at the far ends of a tonal scale. Try blurring your eyes in order to see tone more generally.

TONAL RANGE

The tonal range of your drawing materials will dictate the tones you can represent. Test your materials out to get a scale of light to dark. The white of paper gives you your lightest light, and using different grades of pencil will help you to extend your tonal range.

HB

2B

5B

TONAL MARK-MAKING

Different marks can be used to create masses of tone; create a consistent tonal vocabulary for describing shadows in your drawing. Charcoal can be smudged to create smooth tonal transitions, and pen lines can be hatched or packed more densely to create darker tones.

PRACTICAL BIT: **DARKS, MID-TONES, & HIGHLIGHTS**

To help you see tones clearly try separating what you see into groups
of tone. Develop clear mark-making to represent different tones.
Try not to go too heavy with your tone until you need to, saving your
darkest darks for impactful shadows. Practice drawing a simple ball
lit from a single light source, breaking down the gradient of tone
that you see into groups of tonal value.

dark mid-tone *mid-tone* *light mid-tone*

darkest dark *lightest light*

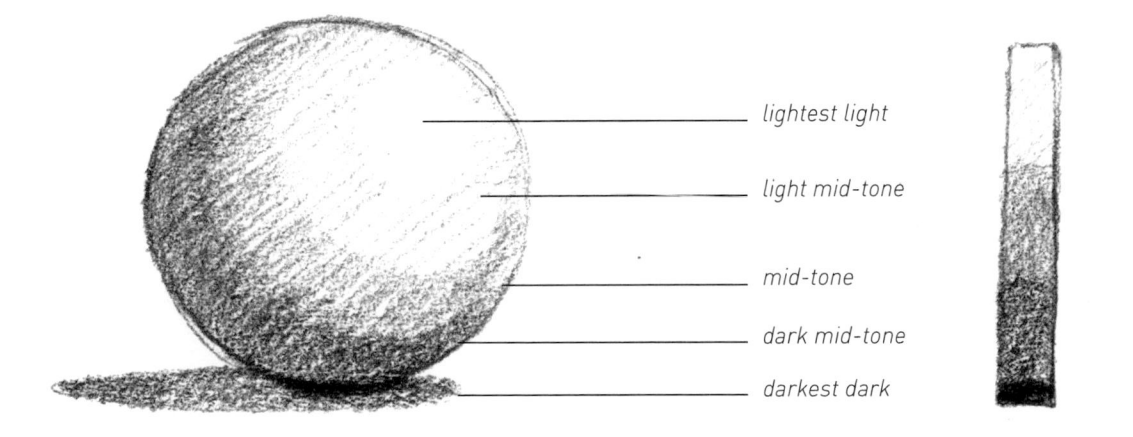

lightest light

light mid-tone

mid-tone

dark mid-tone

darkest dark

THE WHOLE

It is important to maintain an awareness of the whole of your drawing as you make it, and to compare that to your overall impression of your subject. It is easy to get caught up in detail as you draw, but rather than going into detail early on and continuing to work in detail, you'll want to zoom in on an area to see it more clearly, then zoom back out to see how it fits with the whole, make any changes needed, and then zoom back in on another area of detail, and so on.

A drawing to be "assessed."

THE PICTURE PLANE

The first lines to consider when composing a drawing are the four lines that make up the plane on which the picture is drawn. It is within this space that the dynamic masses of the drawing interact. Don't let your paper size arbitrarily set the dimensions of your drawing for you, but take ownership of the picture plane. Decide the dimensions of your drawing and work within that space, or crop a drawing after you have made it. Different dimensions of picture plane will create very different images; experiment with thumbnail sketches to work out how you'd like to crop your drawing.

PRACTICAL BIT: VIEWFINDERS

Take three pieces of card of approximately 6"x8" (15x20cm) and cut a different size of aperture in the center of each one: 4"x4" (10x10cm), 3.5"x7" (8x16cm), and 4"x6" (10x15cm). This will give you three viewfinders that you can use to visually isolate your subject and test different compositions with five different kinds of crop. Draw thumbnails on your paper of the same ratios (1:1, 1:2, 2:3) and try out different compositions; these can be scaled up for more developed drawings.

1:1 ratio

...atio

2:3 ratio

ARMATURES

In the same way as a clay figure might be built onto a wire armature for stability, a drawing can be underpinned with a simple compositional framework. Think of the armature as the simplest linear interpretation of the image, providing little or no hint as to the subject matter. It is a scaffold on which to hang the interacting masses of the drawing's composition. The armature might relate to lines of perspective, directional flows, and halos of focus; it is also important to think about how horizontal, vertical, and diagonal lines cutting through a drawing relate to the outer lines of the picture plane.

When studying another artist's work, look for the underlying armature of the composition. There is no "right" way to interpret the structure; we will all see slightly different key lines. Print out an image of a piece of artwork, lay tracing paper over the top, and intuitively draw in the simplest key lines of the composition. I have taken a Toulouse-Lautrec painting as an example for the compositional study below.

Whenever you are preparing to draw something, consider the view that you intend to sketch and jot down the simplest structural lines that you can see. This will help you compose the masses of the drawing on your picture plane, or encourage you to alter your view to improve the composition.

Look, establish, elaborate

Arranging Masses

When we first look at an image it is the overall arrangement of contrasting masses in the picture that govern where our attention is directed. When you are designing a composition, think about how you can arrange masses of tone or pattern to create balance and direct the eye around the picture plane. The eye is naturally drawn toward areas of lighter tone and strong contrasts. Dark masses can be used to create visual barriers and to channel the eye toward areas of focus. A narrow tonal range will create a muted atmosphere whereas dynamic areas of high contrast will create drama in a picture.

To study how artists use masses of tone in their compositions, lay tracing paper over a printed artwork and block in the major masses of tone, averaging the masses into darkest darks, dark mid-tones, mid-tones, and light mid-tones (see page 154).

Drawing is a selective process. When you are drawing from observation you will make many decisions about how you represent your subject. Once your picture plane is set and a basic armature established, squint or unfocus your eyes to better see average masses of tone. Block in those masses as simple shapes, working in greater detail where you want to create focus.

Linear drawing, tonal masses, elaborate

DIRECTING THE EYE

The route our eyes take through an image is partially dictated by its composition. We are naturally attracted away from dark masses of tone and large blank spaces toward areas of light, concentrations of detail, and subjective elements such as figures, faces, and hands. Think about what your drawing is trying to communicate and how you can guide a viewer's eye around it to better tell its story. A portrait might simply direct the viewer's eye to the face of the sitter, and a still life might simply draw attention to the play of light over a collection of objects. More complex images might lead the viewer through a scene, still life, or landscape, drawing attention to several elements in a planned order.

Using tracing paper and a print-out of an artwork, try plotting the movement your eye takes around an image. It can be tricky to work out at first; don't overthink it but jot it down intuitively.

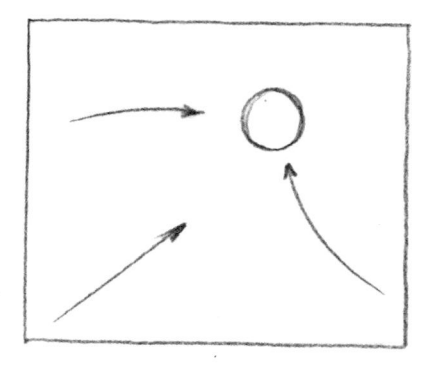

Consider how your own composition directs the eye and make changes to alter the eye's path through a drawing. In this image I have added an additional element to stop the eye falling off the page on the right.

WORKING PROCESS

There is much more to good composition than that which has been outlined on the previous pages, and how you compose a drawing will be led mostly by your own intuition. Although there are conventions particular to different genres of drawing, there are no fixed rules; experiment, learn from the work of others, and develop your own preferences. Here are a few things to consider:

- Consciously decide the dimensions of your picture plane.

- Think about how you crop your drawings—use a viewfinder if necessary.

- Make thumbnail drawings of alternative compositions.

- Consider how horizontals, verticals, and diagonals in your image relate to the edges of the picture plane.

- Arrange your composition into distinct tonal masses.

- Consider how you can direct the viewer's eye around an image.

You can't control every element of your picture all of the time, and neither should you; drawing shouldn't be a contrived, intellectual exercise. However, in order to compose your drawings better, you'll need to control some elements, some of the time. If you're not happy with the composition of your subject, could you do any of the following to improve your situation?

- Move your subject—ask your model to move, or rearrange a still life.

- Change your position—view your subject from a slightly different angle, or get up and move completely.

- Change the lighting on your subject—block or move a light source, create a new light source, or draw at a different time of day.

- Make alterations to your drawing, editing your observations to improve the composition.

- If you're not sure how to compose your drawing, try borrowing the compositions of other artists (see page 72) and think of ways to apply them to your own work (see page 76).

PERSPECTIVE

The conventions of perspective allow us to replicate elements of how we perceive the visual world, and learning these conventions will help you to create the illusion of a three-dimensional space on a two-dimensional surface. By drawing only and exactly what you see in front of you, you can create a representational image without needing to know anything about perspective. However, knowledge of perspective will help you to structure your observations, to anticipate visual distortions, and to convincingly alter and invent drawn environments. Equally, you can choose to distort conventional perspective for your own artistic purposes.

ATMOSPHERIC PERSPECTIVE
Due to the interference of atmospheric particles in the air scattering light, we see significantly distant objects as paler and less tonally distinct, and the colors in distant subjects tending towards blue.

ILLUSIONS OF PERSPECTIVE
A distant object will appear larger to you than a nearby object of the same size and the term "foreshortening" refers to this phenomenon. In the second drawing above, the nearer end of the cylinder appears larger because it is closer; the cylinder appears "foreshortened." When you are drawing and you realize that significant distortions of scale are occurring in your subject you can use measuring techniques (see page 151) to objectively compare the limits of your subject, and negative spaces around the subject to check its overall shape (see page 152).

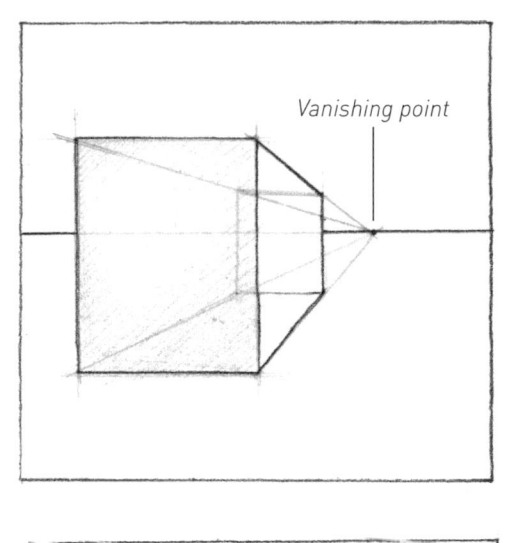

Vanishing point

LINEAR PERSPECTIVE

Linear perspective uses the convention that parallel lines in the physical world appear to converge on a distant point on the horizon in order to create illusions of depth in an two-dimensional image. This is particularly useful to bear in mind when drawing buildings and still-life subjects. There is much more to linear perspective than we have room to cover here. Here are some examples of how to use simple linear perspective.

SINGLE POINT

When a subject has one entire side flat to the picture plane, a single vanishing point can be used to describe the illusion of receding parallel lines disappearing on the horizon. Moving the horizon line will create different views of the same object.

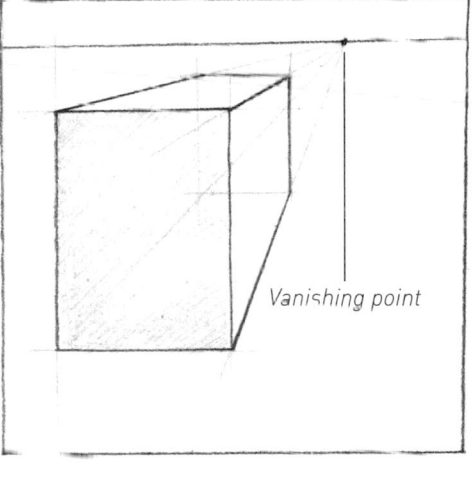

Vanishing point

TWO POINTS

When only one edge of the subject is flat to the picture plane, two vanishing points on the horizon can be used to structure the illusion of the two sets of receding parallel edges of the subject. The vanishing points don't necessarily have to be within the picture plane.

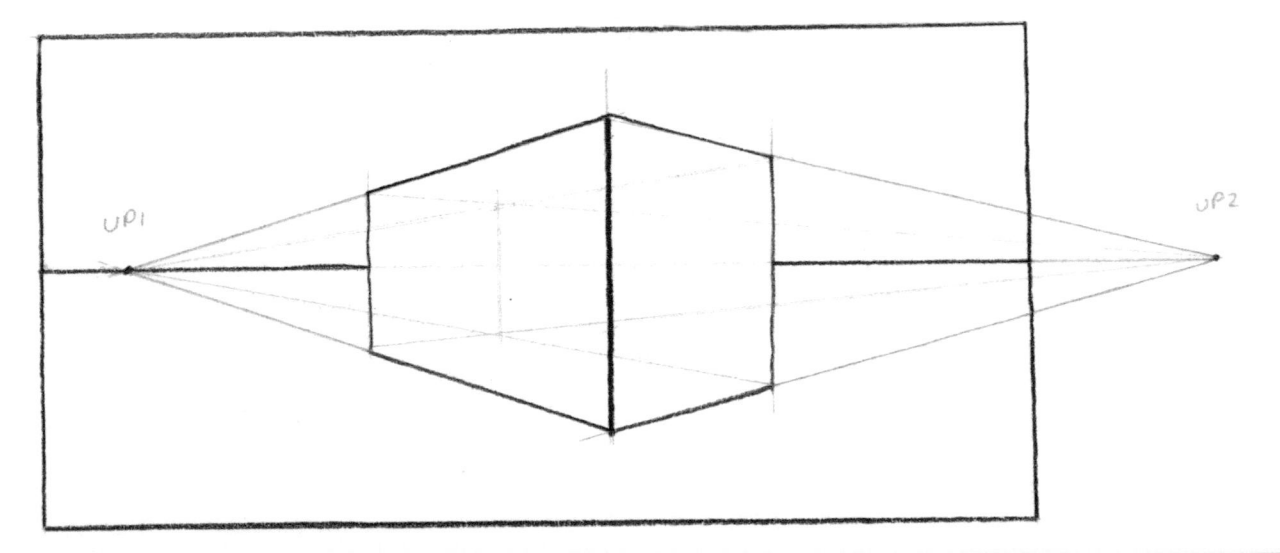

Throughout most of this book we have dealt with drawing in black, white, and gray. To take your drawings further, here is a brief and practical introduction to using color to supplement your drawing. Color is an incredibly exciting and broad topic, so if you are interested in using color more take a look at the reading list at the back of the book. Here you'll find just a few mediums you could use to add color to your drawings.

COLORED PENCIL

Depending on their make and the binders and additives used in their manufacture, colored pencils can be chalky or waxy in feel, and different types of pencil will not always mix with one another. They can be mixed through layering and, much like a graphite pencil, will make clear lines, with blocks of tone and color being achieved through the build up of lots of swift parallel marks. Some colored pencils are water-soluble and can be blended to a smooth watercolor-like wash with a brush and water. Colored pencils need to be sharpened and are difficult to erase.

COLORED PEN

There are many different kinds of colored pen, designed for a huge range of different purposes. I particularly enjoy using inexpensive ballpoint pens for simple one- or two-color drawings, and high quality brush-tipped felt pens for blocking in masses of simple color. The high-quality felt tips blend in transparent layers, becoming darker when overlaid. Take advice from your local art store on what kind of colored pens might suit your drawings.

WATERCOLOR

This book doesn't cover the vast topic of painting, but watercolor can be an excellent addition to a draftsman's box of tricks. Although a challenging medium when used to its full potential, watercolor is a quick and accessible way to add color to a drawing. You'll need to use a heavier paper so that it doesn't buckle when wet—200gsm or heavier is ideal—and the texture of the paper is a matter of personal preference.

A basic watercolor kit includes clean water, paper towels, half-pan watercolor paints, and a palette to mix in, with sable or synthetic brushes suitable for watercolors. A tube of white gouache can make a good addition. The simplest kit pictured here uses a synthetic brush with a self-contained water reservoir.

Add water to the half pans with a brush to make the liquid paint, which you can mix in the palette or apply directly. You will need to work from light to dark, as the transparent watercolor paint uses the white of the paper for its light. Wet paper towels can be used to dab off the pigment, and the opaque gouache can be painted over the top of the watercolor to re-introduce light.

*Pencil line drawing,
light tones, dark tones.*

USING COLOR

Color draws attention in an image, and when you're out sketching you can use watercolor or colored pencils to make simple color notes that can be developed later on.

MIXING

There are many ways to mix colors: wet media can be mixed in the palette and the color applied directly; colored pencil can be mixed in layers and transparent felt tips can be layered over one another. Optical mixing involves placing tightly packed dots or dashes of one color next to another, producing new color effects in the eye.

Layered pencil

Optical mixing in pencil

Mixed watercolors

LIMITED PALETTES

Start simple; to avoid becoming overwhelmed by a full spectrum of colored media, pick out a limited palette of colors to use. This will encourage you to think more carefully about how you mix your colors and will help you maintain harmony in your drawing. As an alternative to a black-and-white monochrome drawing, draw using a single color. The colored medium will most likely be tonally lighter than pencil or charcoal and often works well on a sympathetically colored paper, using a white medium to create highlights.

LAYERING

When experimenting with a more complex color scheme, test your colors and their potential mixes first and try layering up, using one color for the initial drawing and building up tone with a further color, adding accent colors when necessary.

BASIC COLOR THEORY

The notion of primary colors can be misleading. We are often told that red, blue, and yellow are primary colors from which all other colors can be mixed, but in reality this is demonstrably untrue. A primary color is a color that cannot be mixed from any other combination of colors, and the purest oranges or greens cannot be mixed any more than a red or blue. When we draw in color we are limited to the dyes and pigments that can be manufactured into drawing and painting materials. These colors don't represent all of the colors we can see; neither do they reflect the light of a single pure color. By understanding some of the properties of color we can learn to use the materials we have to better effect.

THE COLOR WHEEL

The color wheel can be a useful reference tool for color mixing; it represents an imaginary space in which all colors could potentially exist. It is sometimes made into a three-dimensional color space, with a tonal scale from black to white at its core.

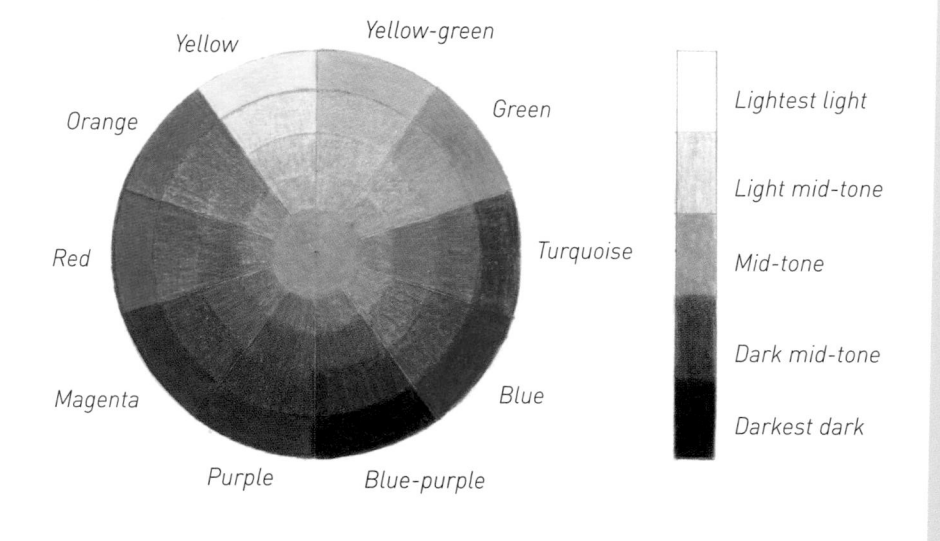

COLOR MIXING TIPS

To mix as bright a secondary color as possible, use two colors that are close to one another on the color wheel. For example, for a bright orange use a golden yellow with a poppy-red, rather than a lemon yellow with a purple-red.

To make a color tonally darker and less saturated, you can mix it with its complementary—its direct opposite on the color wheel.

DESCRIBING COLOR

When we are talking about color we use color names (blue, yellow, etc.) with subjective signifiers to provide further information (lemon yellow, sunflower yellow, etc.), and art materials are often named for the pigments used in them (yellow ocher, for example). These names can be ambiguous and don't account for all the colors we might come across, so it can be helpful to use language that accounts for all the potential colors we could imagine.

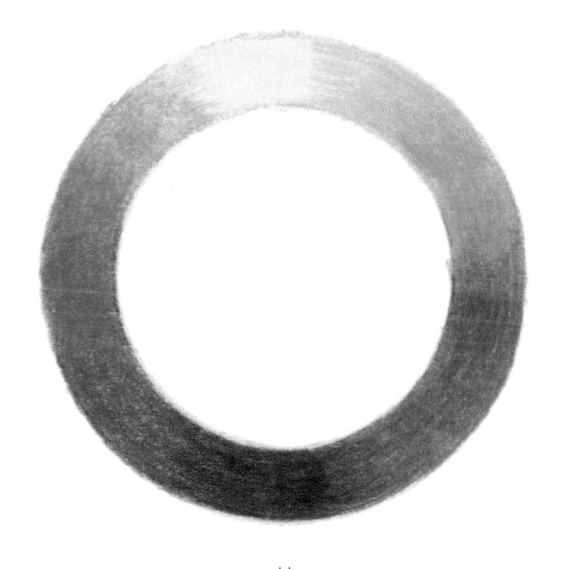

Hue

HUE

The "hue" of a color describes its position around the diameter of the color wheel. At the outer edge of the wheel we see colors in the purest, most saturated state. We could also talk about colors "tending toward" other colors; a green, for example, might tend toward yellow, or it might tend toward blue.

CHROMA

The chromatic value of a color, also called its saturation, suggests its brightness or intensity. Colors are at their most saturated toward the edge of the color wheel, tending towards neutral gray in the middle.

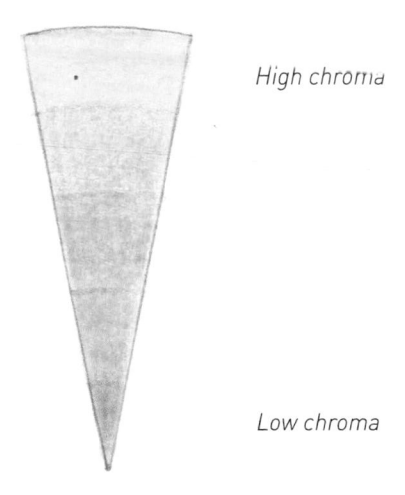

High chroma

Low chroma

This means that we could talk about yellow ocher as being a "low-chroma yellow," or lemon yellow as being a "high-chroma yellow tending toward green." This can help when you are trying to match colors, describe colors to other people, or work out ideal colors to mix.

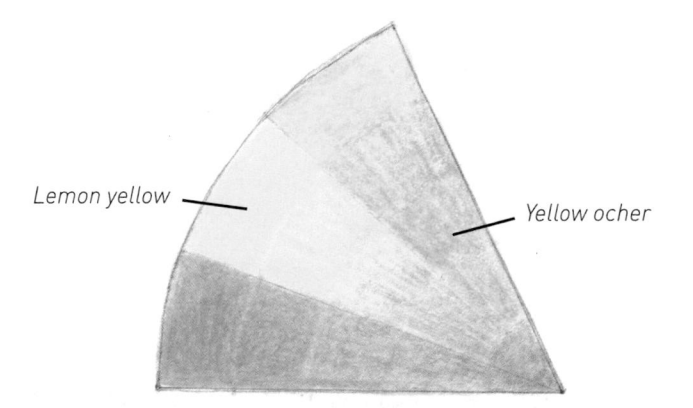

Lemon yellow

Yellow ocher

RESOURCES

This book is intended as a springboard to help you make drawing a part of your daily life. If you'd like to build on the skills you have developed, you can use books to help structure your learning. If you're serious about improving, try using the drawing regimes set out on the opposite page.

Figure Drawing
Anatomy for the Artist by Sarah Simblet
Portrait Drawing by John T. Freeman
The Natural Way to Draw by Kimon Nicolades

Instructional Drawing
Keys to Drawing by Bert Dodson
Drawing Ideas by Mark Baskinger and William Bardel
Fashion Drawing by Michele Wesen Bryant

Drawing Theory & Practice
Elements of Drawing by John Ruskin
Berger on Drawing by John Berger
Drawing Projects by Jack Southern and Mick Maslen

Inspiration
The Art of Urban Sketching by Gabriel Campanario
The Drawing Book by Sarah Simblet

Color & Composition
Light and Color by James Gurney
Color by David Hornung and Michael James
Mastering Composition by Ian Roberts

Other Books by Jake Spicer
Draw People in Fifteen Minutes
Draw Faces in Fifteen Minutes
Draw Dogs in Fifteen Minutes
Draw Cats in Fifteen Minutes

Drawing Classes with Jake Spicer
www.draw-brighton.co.uk
www.jakespicerart.co.uk

Social Media
@BrightonDrawing
#jakespicer

DRAWING COURSES
However much you want to draw regularly it can be difficult to establish the habit of daily drawing in your routines. To kick-start your learning and development, set yourself manageable goals and keep notes on how much drawing you are managing to do each. Here is some general advice to help keep you on track.

- **Identify your goals.** Work out what it is you're trying to achieve with your drawing and aspire toward it; even if you change your mind as you learn, it will help you to find motivation and direct your practice.
- **Ensure you are well equipped.** If you plan to draw in the day, make sure you have all the kit you'll need.
- **Establish a narrative of progression.** Start a sketchbook and carry it around with you everywhere; note some of the exercises in this book down in the back for reference. Look back through the book every month to gauge your improvement.
- **Date your drawings.** Keep your drawings in order so that you can look back through them as you make more, keep everything you draw at first, especially the bad drawings.
- **Set yourself a drawing regime.** If you like structure, write yourself a weekly plan like the examples over the page and stick to it.
- **Set a monthly check in.** Set a monthly date to check in with a friend to show them how you've been getting on, or book a regular tutorial with a drawing tutor. You could even start a blog of images or share them on social media.

DRAWING REGIMES

Here are some examples of regimes you might set for yourself, tailored towards a subject you wish to focus on. To make consistent progress aim to make time for 15–45 minutes of drawing, four days a week, and a single 2–3 hour session with a couple of days where you don't have to draw unless the mood takes you. The long drawing session could be a class that you attend, or work on a more substantial drawing project.

Example Figure Drawing Regime

Monday: 15 minutes — Sketch commuters on the train home after work (page 46)

Tuesday: 15 mins — Practice drawing stick men in your lunch break (page 98)

Wednesday: 2 hours — Attend an evening life drawing class (page 102)

Thursday: Rest day

Friday: 45 minutes — Transcribe a portrait drawing at home (page 74)

Saturday: 45 minutes — Draw a portrait of a friend over coffee (page 28)

Sunday: Rest day — Look over what you've done this week

Example Landscape Drawing Regime

Monday: 15 minutes — Draw out the window on public transport (page 49)

Tuesday: 15 minutes — Sketch a tree in your lunch break (page 58)

Wednesday: 15 minutes — Visit a gallery and transcribe a landscape composition (page 74)

Thursday: Rest day

Friday: 45 minutes — Meet a friend for coffee and sketch the street outside together (page 50)

Saturday: 2 hours — Go for a walk and make a long drawing of a landscape (page 57)

Sunday: Rest day — Look over what you've done this week

Good luck, and happy drawing!

INDEX

ACKNOWLEDGMENTS

This book is dedicated to my Granddad, Bob Barnyard, who has always been supportive of my creative endeavors and kindly sat for the portraits on page 28. This book was made possible by the support and input of the Brighton drawing community and by the ongoing support of my family who have always encouraged me to keep drawing. Thank you to John Freeman, an artist and teacher of great integrity, and to Sarah Simblet and Eleanor Crook for their exemplary tuition and generous advice in the summer of 2014. Thank you also to Shelley Morrow, Hester Berry, Mary Martin, and Laura Burgess at Draw for their ongoing support; to Theresa, Marina, Emma, Milo, Poppy, Jenny, Nicola, and all the other students of the Draw Atelier for being my unwitting guinea pigs; to Tim Patrick for inspiring conversation and to Duncan Cromarty for his ever-valuable input. Thank you especially to everybody who modeled for the drawings in this book: Boris, Kiki, Francesca Cluney, Rob Pretorius, Laura Nenonen, Laura Kate O'Rouke, Lana McDonagh, and Beth Hodd. Thank you to Scarlett for being a willing drawing buddy. Finally, much credit must go to Rachel Silverlight at Ilex for her saintly patience in the face of late content, and to the rest of the Ilex team for their continued hard work and support, and to the designers and printers, without whom the book would not be possible.